HANDS-ON
digital photography

HANDS-ON
digital photography

A step-by-step course in camera controls,
software techniques, and successful imaging

GEORGE SCHAUB

AMPHOTO BOOKS

An imprint of
Watson-Guptill Publications/New York

Acknowledgments

Thanks to all the students in past, present, and future classes who serve as the inspiration and impetus for this book.

Editorial Director: Victoria Craven
Senior Development Editor: Alisa Palazzo
Art Director: Julie Duquet
Designer: Pooja Bakri, Pooja Bakri Design
Senior Production Manager: Alyn Evans

First published in 2007 by Amphoto Books
an imprint of Watson-Guptill Publications
Nielsen Business Media, a division of The Nielsen Company
770 Broadway
New York, NY 10003
www.watsonguptill.com
www.amphotobooks.com

Library of Congress Cataloging-in-Publication Data
Schaub, George.
 Hands-on digital photography : a step-by-step course in camera controls, software
 techniques, and successful imaging / George Schaub.
 p. cm.
 Includes index.
 ISBN-13: 978-0-8174-3491-5 (pbk.)
 ISBN-10: 0-8174-3491-7 (pbk.)
 1. Photography—Digital techniques—Handbooks, manuals, etc. 2. Digital cameras—
Handbooks, manuals, etc., 3. Image processing—Digital techniques—Handbooks,
manuals, etc., I. Title.

 TR267.S332 2007
 775—dc22
 2006037363

Typeset in Helvetica Neue, Adobe Garamond, Din, Berthold Akzidenz Grotesk and Platelet.

Printed in China

1 2 3 4 5 6 7 8 9 / 15 14 13 12 11 10 09 08 07

TO GRACE, AS ALWAYS

CONTENTS

Introduction

The digital single-lens-reflex camera (DSLR) is an amazing tool that combines the photographic and digital worlds—indeed, it's very much like a microprocessor with a lens. It brings together the best of the photographic world (offering control over focus and exposure) with the tools of the digital imaging world (offering control over color and contrast) as if you had your pick of every film ever made on every frame you shoot. Combined with the desktop darkroom, photographers have an entirely new world of photographic excitement and creativity to explore.

The aim of this book is to act as a guided and interactive tour so that you get the most from your digital photography experience. The approach is to present projects that will help you learn as you work with your camera. While there are many projects covering a wide range of topics, the book is divided into three sections: Understanding the Digital Image, In-Camera Controls, and Software Controls. Within these sections, each topic contains a lesson, a brief technical explanation, an exercise that puts the lesson into practice, and an advanced option for exploring the topic in even greater depth. This book is about unlocking the full potential of every picture and then realizing that potential by taking a hand in every stage of its final creation.

This book is not camera- or software-specific. I have worked with, and tested, many digital cameras and image-processing software programs through the years, and have taken special care to include only those features that are common to the majority of cameras and software programs. Although some illustrations are particular to one camera or program, you will be able to understand the terms and translate them to your own gear.

The tools you need to become actively engaged in this book include a digital camera, memory cards, a computer, and an image-processing software program. None of these need be a "pro" or expensive model.

My approach in this book is one that I developed after years of teaching digital photography in universities and workshops around the country and the world. Digital photography can have a steep learning curve. While many students became both excited and proficient in many digital matters throughout these courses, it was what happened *after* the class that inspired this book. There was so much to learn that retaining all the aspects of the craft after the class was over proved difficult. Students asked if there was a book that handled each of the techniques in a how-to way, working in step-by-step fashion, with lessons they could revisit and repeat long after the class was done. They also wanted a practical approach to learning, one that they could apply in their own photographic endeavors.

This book, I hope, will answer that need, as well as serve as an outline and a background for other teachers sharing their knowledge of this exciting new form of photography.

Part One

UNDERSTANDING THE DIGITAL IMAGE

□□□□□□□□□□□□□□□□□■■■

Pixels: Picture Elements

The word *pixel* is derived from a combination of the words *picture* and *element*. Pixels are the "cells" of an image, yet they don't have membranes, a nucleus, or other physical attributes. They are, in fact, codes that describe a certain brightness, color, and, in relationship to other pixels, contrast. The codes are only visible when "translated" by a graphical user interface, a computer (or a microcomputer in the camera) with attached monitor. An image can be composed of millions of pixels and millions of codes. Each of these pixels has what you could call an address, a specific set of instructions that tells the computer system that, for example, a "bright red of X character and brightness" sits in one of the cells.

If we were to picture the cells individually, they would be square, rectangular, or some polygonal shape that looks like a tiny paint swatch. But put side by side, miniaturized so that there are thousands of cells per inch, they begin to form a cohesive picture. Have enough pixels within a frame and they can create the illusion of a continuous-tone picture—a photograph. When a digital image is formed on a screen, it is a back-lit image, illuminated by phosphors. When printed, a digital image is composed of dye or pigmented ink that are, in most cases, sprayed onto paper in fine dot patterns that correspond to the pixel addresses. In either case, the pixel address is at the heart of the image. But it is a mathematical construct, rather than a physical thing, prior to it being translated on screen or in a print.

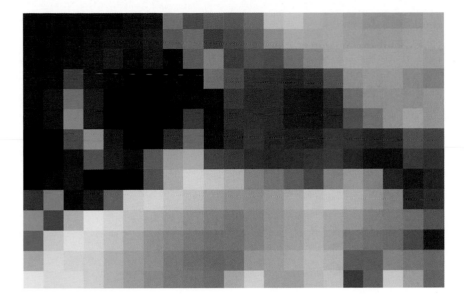

When composed of millions of pixels, digital images can be enlarged considerably and still show all the colors, subtle shifts, and tints of light that describe what a photograph is—a continuous-tone reproduction of a scene recorded by a camera that creates a reasonable representation of visually perceived reality.

When greatly magnified, the individual pixels become apparent, thus revealing the construct or building blocks of the digital image. This section was taken from the center of one of the flowers opposite and shows a host of pixels packed together to form the image.

Try It

Open any image on your computer screen, and choose the zoom tool from your photo-editing software. Place it over any part of the picture, and keep clicking the mouse until the image can no longer enlarge. This should begin to show you the "translated" pixel construct of the image.

Advanced Option

If you're working in Photoshop, after you get the highly magnified image on the screen, go to Filter>Pixelate>Mosaic to get a highly defined simulation of the pixel structure of the image.

Unsharp Mask	⌘F
Extract...	⌥⌘X
Filter Gallery...	
Liquify...	⇧⌘X
Pattern Maker...	⌥⇧⌘X
Vanishing Point...	⌥⌘V
Artistic	▶
Blur	▶
Brush Strokes	▶
Distort	▶
Noise	▶
Pixelate	▶
Render	▶
Sharpen	▶
Sketch	▶
Stylize	▶
Texture	▶
Video	▶
Other	▶
Digimarc	▶

Color Halftone...
Crystallize...
Facet
Fragment
Mezzotint...
Mosaic...
Pointillize...

File Formats

The digital image is information; it is not composed of dyes or silver deposits or anything that, without software and a computer, resembles anything like a picture at all. Should its code be printed out, it would be a string of numbers. That code is translated via computer and monitor to resemble an image.

The single image is often referred to as a *file*, as it stands alone as an entity; it often resides in a *folder*, which is a group of files that share certain attributes or associations. Either you give it these attributes, or they are assigned by the system when you download from your camera to the computer (by date, for example). To make the folder more photographer friendly, it is often called an *album*.

Like all computer files, digital images have a certain structure that makes them readable. That structure, or format, is identified by a three-letter extension on the file name. Common extensions in digital photography are .jpg, indicating a JPEG file, and .tif, indicating a TIFF file. These file names are acronyms that stand for Joint Photographic Experts Group and Tagged Image File Format, respectively. Not very helpful names, but that's what they're called.

The third format—and, increasingly, the most commonly used—might have any number of three-letter codes. Generically, it's known as *raw* format, but may have extensions such as .crw, .nef, or .orf. These odd-sounding extensions are private codes assigned by the manufacturer of the camera. Each of these file formats are proprietary, which means that only software made by the manufacturer (or software made by another company that has reverse-engineered the manufacturer's code) can open and read that file as an image. This, frankly, creates a bit of a mess, but more generalized raw formats, such as .dng, may be more universally accepted as time goes on.

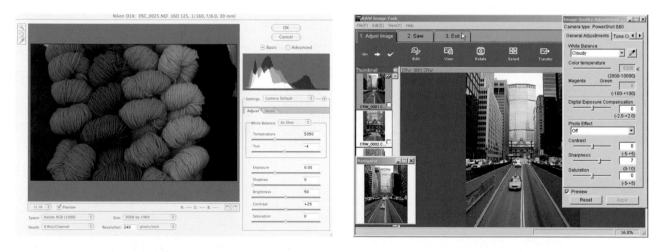

Raw files require further processing after downloading to be able to be worked on in creative imaging software. This screen shows the various "attributes," or image characteristics, that can be adjusted and changed, all without damaging or changing the original file. When done, you would use the Save As command to save the image as a JPEG, TIFF, or raw file without affecting the original image file. Note that most of the adjustments available are also available as camera programming options that you select before you make the picture. Raw will retain this information but will not "close out" the file, making it much easier to change—correct or enhance—later.

There are as many raw converters as there are camera manufacturers, and some of them do a better job overall than others. This screen above is from a camera manufacturer's software, circa 2006. Improvements in raw file processing will keep coming, so check the manufacturer or software maker's Web site often for updates.

Regardless of the variations on the raw theme, raw files all share certain common traits. Both JPEG and TIFF files are fully processed in the camera to convert the electronic signals from the sensor to binary information. With raw, that processing is left open-ended and is not entirely locked down when it is done. In essence, raw format leaves the final stages of processing to the photographer. This processing is done via raw converters that allow for many changes to and refinements of the original image file. However, JPEG and TIFF file formats are still universal, so most raw converters do convert the raw, now-processed data to .jpg or .tif format as the final step. Adobe's .dng format doesn't usually need to be converted if you're working in Photoshop, but it must be converted to be readable on a non-.dng-compliant software or system. Sound confusing? It can be, but only if you delve too deeply before you have a chance to work with the different formats. In practice, it all begins to quickly make sense.

There are really only two rational choices in digital photography today: JPEG and raw (whatever your camera's proprietary raw format might be). Indeed, TIFF has become more of a software format than a camera capture format. Much of this has to do with file size and the differences between raw, JPEG, and TIFF file formats. To understand the differences, and why TIFF is essentially a software format, the concept of compression needs to be introduced.

Compression

Regardless of file type, much digital information is compressed before it is stored. Music files and video files, which can contain a lot of information if aural or visual fidelity is valued, are commonly compressed prior to storage and then uncompressed when opened or played. This is done to save disk space and unburden the drives where the information is stored. The compression and reopening is coordinated by what are called *algorithms*, which are mathematical formulas that define what can be tossed away (and information is, literally, tossed out) and then reconstructed when the image is opened again. All formats that toss away information prior to compression are called *lossy* files, and those that don't are called *lossless*.

It should be obvious that when it comes to an image, you want to work with a format that is as lossless as possible. This preserves the colors, line, and subtle play of light and shadow that together make for a pleasing image. You also want to gather as much information as possible so that you can work with as many variations on the image as possible later. Less information makes for fewer creative opportunities, something that will become obvious to you as you grow in your work.

Of the two universal formats, TIFF and JPEG, TIFF is the lossless option. It doesn't compress the file information as it lands on the memory card after image processing. It also incorporates all the image attributes or character you may have programmed in during your photography, such as enhanced color saturation, application of exposure compensation, and white balance settings. It's all in a bundle, noncompressed, and can be read by every image-processing software program on the planet; plus, it can be attached to and opened in e-mails and other forms of Internet communication.

The only problem with TIFF files is that they are large. Shoot a TIFF on a 10-megapixel (MP) camera and you have a near-30-megabyte (MB) file for every shot you make. If you have a 256MB card, that's only nine shots per card. Obviously, memory card prices and capacity make this less of a problem than it was previously, but it was enough of a problem in the recent past that TIFF disappeared as an option on most digital cameras.

The solution was, and to a certain extent is, the JPEG file. Being a lossy format, JPEG compresses the information after processing, according to a certain ratio that you define when you shoot. It varies according to model, but generally it's a compression of 1:4 (Fine or Large), 1:8 (Normal), or 1:16 (Economy or Basic). You still get all the attributes you programmed in when you shoot, just like TIFF, but the file size is smaller, according to the ratio you chose when you shot. Given that you're working with a 10 megapixel camera, at 1:4, the stored file size is 7.5MB, and at 1:8, it's 3.75MB per file, allowing many more images per card than TIFF. In each case, when you reopen the file on your computer, it will open to the "full," noncompressed file size. But keep in mind that that fullness is a result of reconstruction of information—and not of all the original image information. This might not be very obvious at 1:4, but it becomes more so at 1:8 and very obvious at 1:16.

JPEG files also allow you to shoot using less than the maximum pixel resolution on a sensor. This is usually shown on the Quality menu as *resolution options*, with lower pixel dimensions indicating smaller overall file sizes, regardless of compression. Why do this? In some cases, you might not need or want a large file, such as for Web pages, blogs, or e-mail attachments. Many programs now automatically "resize" your images for these uses, but why waste disk or memory card space if you never intend to use the large file sizes for big prints?

The raw option more or less combines the benefits of both JPEG and TIFF files, but does so with a price: You have to take the time to "process" the image after you download it. It is a lossless file format, in that it doesn't toss out information when processed. It also creates smaller file sizes, usually from 40 to 60 percent smaller than TIFF, thus saving on disk and memory card space. This economy of space is created by leaving the raw file "open ended" during camera processing.

A QUICK COMPARISON OF FILE FORMATS

File Format	Compression	File Size* (6-megapixel sensor)	Quality**
TIFF	None	18MB	Very good
JPEG	1:4	4.5MB	Very good
JPEG	1:8	2.25MB	Good
JPEG	1:16	1.125MB	Fair
raw	None	@7.2MB	Excellent

*File size when stored
**Based on 8 x 10 print from file

You choose the file format, resolution, and compression via the camera recording menu. Some camera bodies have a Quality of File button that when pressed shows the options on the LED or LCD display. You then toggle through the choices and pick file format first and then compression. File format will be either .jpg, .tif if available, or raw (indicated by whatever raw file extension the camera maker uses). If you choose .jpg, you'll have a number of options, including resolution, indicated by various pixel dimensions (2560 x 2200, for example). If you're photographing for prints, choose the largest resolution; for e-mail or Web, choose the middle or lower resolution.

The compression of the file will usually be indicated by terms such as Super Fine, Fine, Good, Basic, Economy, or symbols that indicate those terms. Check your instruction manual to match compression ratio with terms used. For the best quality images, choose raw. For the best quality .jpg images, choose the highest resolution and lowest compression ratio. For Web or e-mail and space utilization, choose .jpg format, second from highest resolution, and the middle (usually 1:8) compression.

When TIFF and JPEG files are processed, all the image information and camera programming you performed is processed and placed within the file. When a raw image is used, all the programming you did is still part of the file but is treated as instructions that *travel along with* the raw file, rather than as information embedded in the file. The distinction might not seem that profound, but in practice it makes a big difference in what that file allows you to do and how it is treated later in software.

One of the main differences is that raw files are higher bit files than JPEGs or TIFFs. Both JPEG and TIFF formats are 8 bits per channel (bits/channel) RGB files; raw files can be 12- or 16-bit files, depending on the model. More bits mean more image information, thus raw files are richer from the get-go. In addition, raw files are not ever closed down during in-camera processing or postprocessing. They can be changed in software in just about any way that you can change them in the camera when making pictures, such as by adjusting color saturation, contrast, and so on. So, for these reasons, raw format is the most flexible and information-rich imaging format in digital photography.

This malleability and greater richness of image information make raw files very attractive to those who want to get engaged in the processing of their image files. This is very much the control those who processed their own film enjoyed in the past. However, not everyone wants or needs to get that involved; that's where low-compression, high-resolution JPEGs come into play. In addition, new file formats are coming that may well eliminate the need to choose between disk space and ultimate image quality.

Raw format gives you the most imaging options with the greatest amount of image information in each file. Making changes is quite simple—much easier than shooting in JPEG or TIFF and trying to change, correct, or enhance those file formats. This is the original as shot, with image characteristics and all, in .nef format (Nikon's raw file).

I changed the white balance on this raw file with one click in the raw converter software. As shot, it was Daylight white balance; the resulting Shade white balance is a much warmer (yellow) rendition.

Try It

Shoot a number of subjects and scenes as JPEGs at the highest resolution and lowest compression ratio; then, make the same images with the lowest resolution and highest compression ratio. Download the images and compare them on screen, using a zoom tool to magnify the images to make the differences more apparent, if necessary.

Here, I altered the hue and saturation in the raw converter software.

It's very easy to convert to black and white when shooting in raw format. Most cameras allow you to shoot in color or black-and-white mode in the camera and then convert in either direction if you shoot in raw.

Advanced Option

Shoot in JPEG format at the lowest compression ratio and highest resolution, and then photograph the same scenes in raw. Process the raw file so that you have a number of different variations, using the raw software available to you. Next, open a JPEG file and attempt to match the raw variations. Note the work and time requirements between the two.

Resolution, Resizing, and Resampling

Resolution in a digital image is defined as the numbers of pixels per inch in that image. This is fairly useless information. What resolution determines, however, is more important: how good your image will look when you use it for a print, for a Web image, or as an attachment to an e-mail.

You do have a number of resolution choices to make when making photographs. One, as just covered, is the file format. You have two main choices these days—between raw and JPEG. If you shoot raw, then all your resolution choices are made already (the camera shoots at what is called *full resolution* each time). If you shoot JPEG, you might have three or more choices to make: Large (or Fine), Medium (or Normal), and Small (or, in some, Economy). All JPEG files are compressed when recorded, but the "size" choice is separate from compression and lets you choose how many pixels on the sensor you will use to make the image.

My advice for JPEG shooters is to use Large, or Fine, for every shot and then resize the images later for other uses. If you shoot with lower resolution, you may not be able to use the image for every use later and will sacrifice quality if you try to use lower-resolution images for making print enlargements. Note that a number of cameras now let you choose raw and JPEG files simultaneously when you make your format/resolution decisions—the best of both worlds.

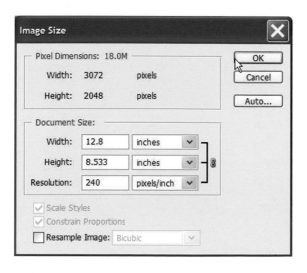

Here's the Image Size dialog box (from Photoshop) for a full resolution image from a 6-megapixel digital camera. You use this dialog box as part of the printing process. When you first open an image from your digital camera, the dialog box might show a resolution of 72 pixels per inch (ppi). Note that some cameras automatically open at 300 ppi or allow you to set the "opening" resolution.

The ppi here indicates that there are 72 pixels in each linear inch of this 18MB file, which is composed of a horizontal count of 3072 pixels and a vertical count of 2048 pixels. So what? The important matter is how these numbers translate to usefulness. In this printing setup, it seems that you could get about a 42 x 28–inch print from this file. Pretty impressive, but the print would look horrible. You have to convert from the "opening" resolution (72 ppi here) to the printing resolution that yields a good print; this can be anything from between 200 to 300 ppi, with most folks agreeing that 240 ppi is a good, responsible number for quality prints you make yourself.

With the resolution set at 240 ppi, the dimensions of the image change, and you will get an excellent roughly 12 x 8.5–inch print. Likewise, if you have less resolution to play with (say, if the file size were 9MB), then you could also get a good print, but only if you print at a smaller size.

Resizing vs. Resampling

Web images and e-mail attachments should not be as large as the 18MB in the examples opposite, as even with the faster speeds of transmission available today, such file sizes will crawl over the lines. But this doesn't mean that you should necessarily shoot at smaller-resolution settings, thus getting smaller file sizes right out of the camera. If you shoot at the Best, Large, or Fine setting it's easy to resample the image for Web and e-mail transmission.

There is a difference between *resizing* and *resampling*. Resizing is taking the current pixel dimensions of the image and changing the numbers within those parameters. In other words, changing print size by manipulating the resolution number. You can get a 5 x 7– or 8 x 10–inch print from, say, an 18MB file. But to get to the 5 x 7 from the 8 x 10, you resize the print by changing the resolution, or ppi setting, in the Image Size dialog box. You can print at 240, 300, or 600 ppi (not that you'll see much of a difference when you do), but you only change that number to change the actual print size. You still have an 18MB file.

Resampling is actually adding to or throwing away some of the pixels in order to either increase print size from a file (a matter we won't cover here) or reduce the size of the file to make for easier transmission. Resampling is a careful calculation that creates models of how the image can hold onto its integrity with less information. The example on pages 22–25 is a resampling for use on the Web.

Note that many Web programs and e-mail attachment protocols only allow for certain file sizes or formats; so, you should note these requirements/restrictions before preparing your images for regular addressees or destinations. Most will accept JPEGs; very few will accept any raw file formats. In addition, some programs will automatically resample when you upload your images, but that may slow transmission considerably depending on whether the resampling is done in the computer prior to upload or when the server receives the upload through a "filter" of sorts and downsizes the images automatically as it receives them.

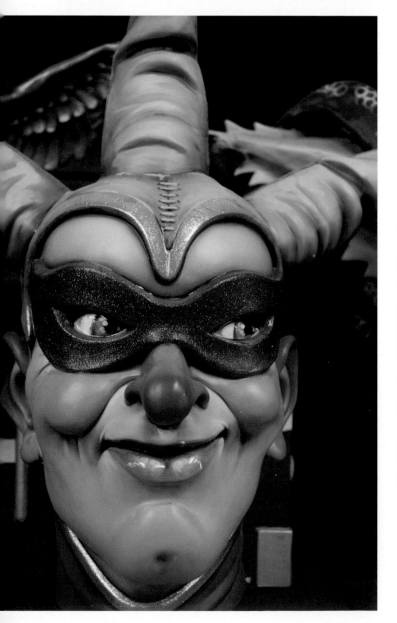

The examples on the next few pages show an easy way to resample images shot at full resolution for Web and e-mail use. I'm using an 18MB image file shot at full JPEG resolution with a 6-megapixel camera.

Opening the Image Size dialog box shows the pixel resolution and a high-resolution ppi for printing. This will yield an excellent 10 x 14–inch hi-res (high-resolution) print. This will yield an excellent roughly 6.8 x 10–inch hi-res (high-resolution) print at 300 ppi or a very good 10 x 14–inch print at 240 ppi.

New...	Ctrl+N
Open...	Ctrl+O
Browse...	Shift+Ctrl+O
Open As...	Alt+Ctrl+O
Open Recent	▶
Edit in ImageReady	Shift+Ctrl+M
Close	Ctrl+W
Close All	Alt+Ctrl+W
Save	Ctrl+S
Save As...	Shift+Ctrl+S
Save a Version...	
Save for Web...	Alt+Shift+Ctrl+S
Revert	F12
Place...	
Online Services...	
Import	▶
Export	▶
Automate	▶
Scripts	▶
File Info...	Alt+Ctrl+I
Versions...	
Page Setup...	Shift+Ctrl+P
Print with Preview...	Alt+Ctrl+P
Print...	Ctrl+P
Print One Copy	Alt+Shift+Ctrl+P
Jump To	▶
Exit	Ctrl+Q

One of the easiest ways to resample an image or a set of images (via a function known as *batch processing*) is to use the Save for Web tool, which may go by various names in different programs. In Photoshop, go to File→Save for Web once the image you want to resample is open on your monitor.

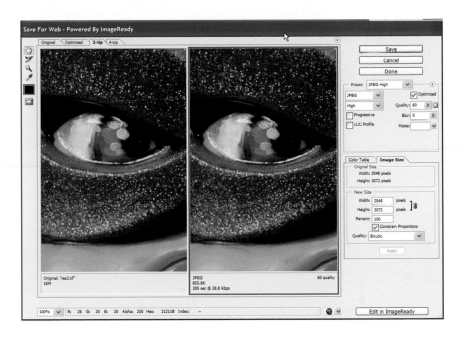

The Save for Web dialog box contains a number of items. On the upper right in the Preset section of the dialog box, make sure that the file format shows as JPEG and that it is set to High. A bit below that are two tabs, one for Color Table and another for Image Size. Click on Image Size. This is the box in which you adjust the information for resampling. Note that the size of this image is 2048 x 3072 pixels, or an 18MB file.

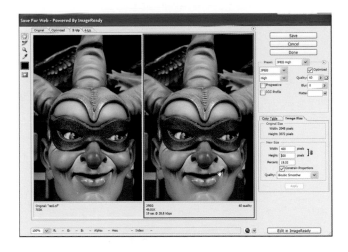

Different Web pages and e-mail programs will have different required sizes, but one I use often is 600 pixels for the longest dimension of the image. Some will have less or more. In any case, type that number into the New Size section of the box in the field for the longer dimension. There's no need to type in the other pixel dimension as long as you have the Constrain Proportions box checked. This keeps the aspect ratio, or relationship of width to height, the same.

Once you've typed in the desired size, click the Apply button, and the program will go to work and yield this screen. If you don't see this screen, look at the tabs that appear at the top of the image, and click on 2-Up. You then hit the Save button, and place the image in a Web image folder or wherever you desire.

Resolution is composed of a set of numbers that tells you the quality level you can expect when you do some form of output with your digital image file. In general, the larger the image file size (or resolution), the bigger the prints can be made. From pixel resolution, you get a file size, which you find by multiplying the pixels per inch in the horizontal and vertical dimensions of the sensor (called the *effective resolution*), and then multiplying that number by 3 (for the three layers of RGB). To simplify matters, rely on the final file size (of the image open on your screen) rather than the pixels per inch as your guide. In general, an 18MB file is a good benchmark, as it allows you to get a very good 8 x 10– to 11 x 14–inch print, provided exposure, focus, steadiness, and so on are all good.

When you change the print (or document) size using a set file size, you are resizing that image file so that it fits your printing needs. You do that in the Image Size dialog box (accessed from the Image pull-down menu in Photoshop), where you type in the desired print size, and any program will calculate a new resolution (ppi) to match.

To change the file size in order to make it bigger (for larger prints) or smaller (for e-mail transmission, for example), you resample the image file. This brings sophisticated mathematical models into play that throw a certain amount of image information away or construct new information without degrading the overall image quality.

Here's the image, now at its smaller size. It has dropped from 18MB to under 1MB. Note that even when the image is resampled "down," image quality is still very good.

Image Size

Pixel Dimensions: 703.1K

Width: 400 pixels

Height: 600 pixels

[OK]
[Cancel]
[Auto...]

Document Size:

Width: 5.556 | inches

Height: 8.333 | inches

Resolution: 72 | pixels/inch

☐ Scale Styles
☑ Constrain Proportions
☐ Resample Image: Bicubic

The actual size of the file, however, is even smaller than the 700-some-odd kilobytes the Save for Web tool accomplished. That's because when it's converted to JPEG, it is also compressed, which can result in an even smaller file for transmission. You can determine the size of the final file by how much you choose to compress the image via the Quality setting in the JPEG Save dialog box. Keeping it at a High setting, such as 8, maintains good image quality and shrinks the file size to under 100K, which will open to its full 400 x 600 pixel size later.

Try It

Choose an 18MB or similar size image, open it, and then use a resampling program to shrink its size for Web page or e-mail transmission. Use the Save for Web or a similar tool. Open your e-mail program after you've saved the image at a good Web size, and send the Web-size image to a friend, associate, or yourself. Now, do another similar message using the full (in this case, 18MB) file size. Note the different experience in both the sending and the transmission of the image with each approach.

Advanced Option

Open the full-resolution version and the resampled version from the Try It exercise and make prints from each. Start at 4 x 6 inches and work your way up to 8 x 10 or 11 x 14, and note when quality might begin to deteriorate when using the smaller file size. Note how the 18MB file must be resized to go smaller than 8 x 12 or so and how the smaller file size has to be resampled to go larger. Work within the Image Size dialog box so that you begin to understand the relationship between pixel dimensions, file size, document (or print) size, and resolution.

RGB Channels

The sensor in a digital camera or recording device is akin to a microphone. It detects stimuli, converts them to an electrical signal, and then passes that along for processing. The sensor in a digital camera is a monochrome, or grayscale, recording device over which is placed a checkerboard pattern of red, green, and blue (RGB) filters. As the light passes through the lens toward the sensor, it passes through these filters, which sort out the colors that become part of the information that goes to the camera's image processor. The digital image processor reintegrates the signals to create a binary code of pixel addresses. These can then be read by a computer and translated on a monitor to form a full-color image.

Each RGB component is called a *channel*. In many images, each of the three channels within a pixel holds 8 bits of information, or code, creating a 24-bit image. Some camera sensors and scanners can record higher bit depth, which allows for even more colors and subtle shadings of light. These 12- or 16-bit (per channel) images are usually sourced from shooting in raw image format. The combination and brightness of those colors make for millions of different possibilities of hue, tint, and color saturation.

Red channel.

Green channel.

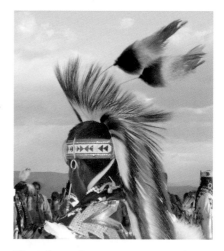
Blue channel.

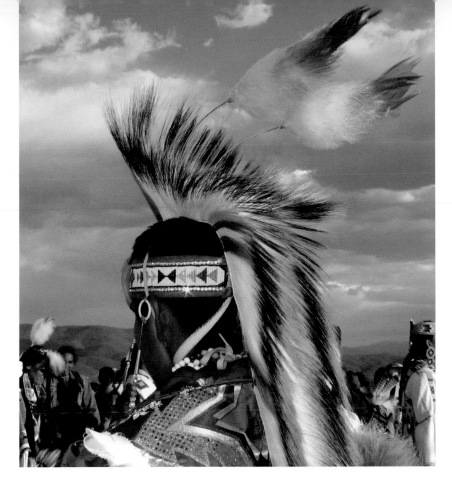

The full-color RGB file.

How It Works

When you break a digital image down into its components you get red, green, and blue channels, which, when combined, create a full-color image. Color photography has always worked by combining colors that were recorded through a "resist" of filters, which allow their own color to pass through while blocking other color light. Color-film structure is quite similar, although in film, the image record is composed of dyes, whereas the digital record is composed of pixel "addresses" that identify a certain hue, shade, and saturation of color.

Try It

Open an image on your computer, and find the Channels view. Open the Channels palette, and start to turn the various channels off and on. (In Photoshop you access this by selecting the Channels tab in the Layers/Channels/Paths toolbox.) Note the blending of color when two channels are on and one is off, and how each combination affects the image color.

Channels dialog box.

Layers	**Channels**	Paths
👁	RGB	Ctrl+~
👁	Red	Ctrl+1
👁	Green	Ctrl+2
👁	Blue	Ctrl+3

Advanced Option

You can use Channels to convert a color image to grayscale, or black and white. Open the Channel Mixer dialog box and check Monochrome. (In Photoshop, you access this under Adjustments in the Image pull-down menu.) Then, use the sliders to remix the channels for different black-and-white effects.

Channel Mixer dialog box.

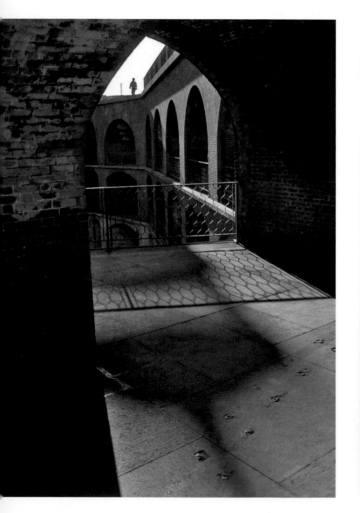

Original color image.

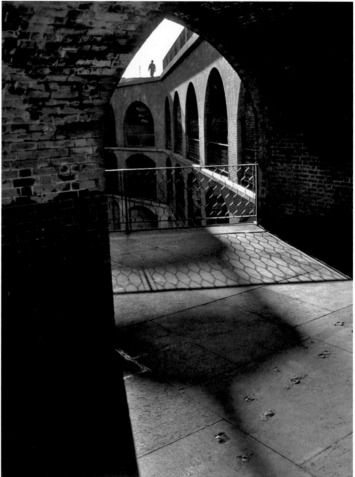

Black-and-white conversion.

Color

The basic building blocks of color in a digital image are codes that represent red, green, and blue. These codes are generated by signals received from the sensor, where light has been split into red, green, and blue components by a checkerboard-patterned filter that sits between the lens and the sensor plane. The codes contain the hue (the color), the color brightness (the light and dark or neutral gray contrast), and the richness (or saturation) in the color record. As the signals are converted from electrical to binary code, the reintegration of those color components takes place.

Digital images can reproduce millions of colors. The numbers of combinations of hue, richness, and brightness are quite amazing. There can be hundreds of variations on "red" or "green," all expressed by slight changes in a pixel's digital address or code. The color play is enhanced further by how colors interact with one another. Just as an example, there could be a group of red "2" pixels right next to a red "4" pixel that changes the way we see both colors or, with smaller dots or groups, blends the colors so that the two become a third.

So, the illusion of continuous color and tone in a digital image comes from these sensor-generated electrical signals that are made into binary numbers by an image processor. These codes correspond to image information that, when translated on the screen as pixels, becomes colors, tones, and tints. There can be thousands of these discrete pixel code boxes per inch, which when packed tightly together make the grid of boxes seem like a continuous-tone photograph. Compare the full image with its enlarged pixel detail on pages 12–13.

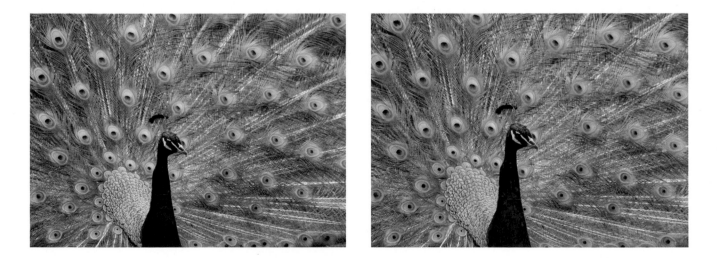

Digital images are capable of capturing an incredible range of colors and brightness values. The ability to enhance these attributes in camera and later in software makes for even greater creative potential. This pair shows a very colorful image made even more so via software processing.

There are many factors that can affect the recording and reproduction of color. First, there's the unique way that certain camera sensors and image processors record color. Then, there's the way you have your printer or screen monitor set up. There are also many modifications that can be made before and after the image is recorded. There are so many variables that color, for many, will be, at best, a subjective experience. This is fine, as long as the color that does result matches what you expect or how you want the image to look.

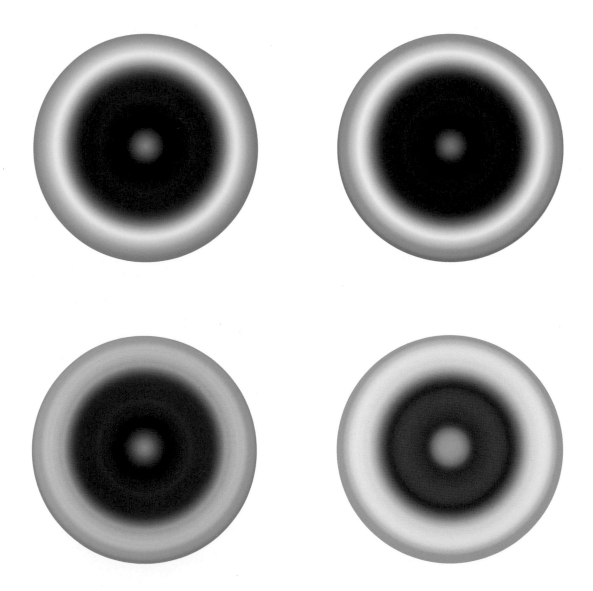

Color options abound in both the camera and the software. Color is manipulated every step of the way, from the camera default color recording to how you choose to change it yourself. The color circle at top left represents this particular camera's default color setting. The camera delivers a very acceptable range of hue, contrast, and saturation. The color circle at top right reflects an increase in saturation, which is something you can easily set in camera or in software. The circle at bottom left shows a decrease in the yellow color saturation only, a very simple adjustment that isolates and subdues one color only. The last of these variations, bottom right, shows how a decrease in contrast affects all the colors shown in the image.

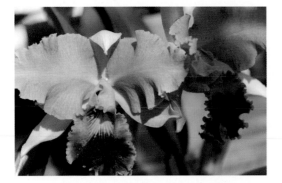

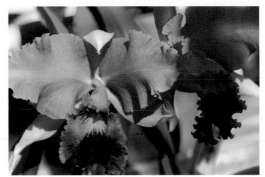

To see how adjustments in hue, saturation, and contrast affect an actual photograph, compare the examples here. I photographed this orchid in bright daylight conditions inside a greenhouse. The colors and contrast top left match my memory of the plant quite well. It's an objectively correct translation from the scene.

Objectivity and photography don't always go hand in hand, however, and top right, the same image has been enriched with a gain in saturation and contrast, applied in software well after the exposure was made. There's always room for interpretation in digital photography; indeed, the freedom it allows for creative interpretation later is one of its main attractions. In the image at left, I decreased the contrast to yield a more ethereal interpretation of the orchid.

A brief glimpse into the possibilities is available in image-manipulation software programs, such as Adobe Photoshop. Below is the Variations dialog box under Adjustments in the Image pull-down menu. To change the image to any of these options, all you need do is click on the interpretation you like and hit OK.

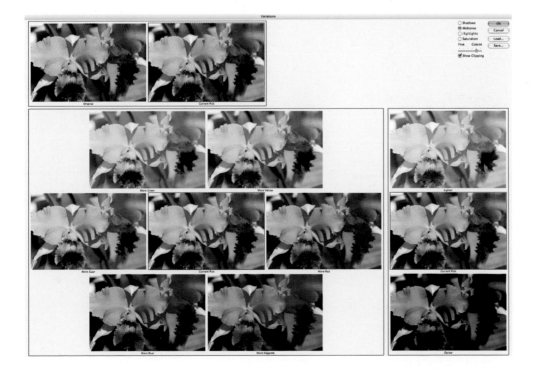

Color Options

Each camera processes color in a slightly different way. The settings on the camera out of the box are called the *default settings*, which usually are quite good but are also the "opinion" of the manufacturer as to how color should record. While there are standards, and ways to calibrate color to them, it is almost impossible to have an out-of-the-box camera match all the variables that may exist in your computer and printer. The time and energy you take to attain and maintain strict calibration standards should depend on how critical "exact" color is to you. Some variations, all of which can be fixed or tweaked quite easily, are to be expected.

Default settings should not be taken as law. Indeed, many are made to be changed. As you work, you will discover the settings that record color in a way that best expresses your vision or that serve each subject and scene to best advantage. Not all the color control options that follow may be offered in your particular camera. If you don't have an option shown here, you need not be concerned, as there are plenty to choose from even in basic digital cameras.

Color Space

The term *color space* is taken from color science; it refers to a 3-D map of color fidelity and how colors can be perceived by the eye or reproduced within a certain medium. All this is quite academic, and the terms used are more confusing than they need be. Essentially, there are two color space options in digital cameras: sRGB and Adobe RGB. The sRGB space is the most common and should be used if you're sending images directly to a printer for direct printing or if you're making prints using a kiosk. This color space tends to yield bright, fairly saturated colors. Adobe RGB is a broader color space—that is, it can reproduce a wider range of colors, but those colors tend to be "flatter" and more saturation-neutral than sRGB.

What's the practical application of this? If you want to get the widest range of colors without saturation enhancement, choose Adobe RGB. This is a good model to work with if you're going to be doing your own image processing and printing. The other model is a bit more compressed in its range of colors and

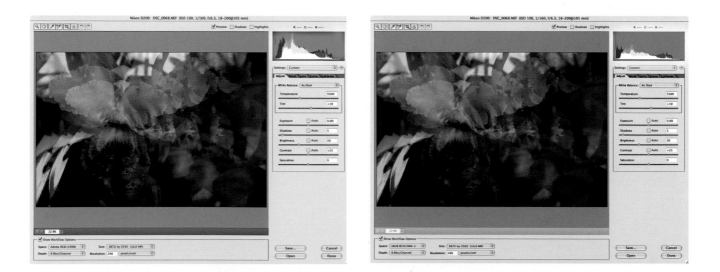

You probably won't see much, if any, difference on your monitor when selecting different color spaces, but checking the color histogram in the Adobe Camera Raw software from both an Adobe RGB color space and an sRGB color space reveals that there is more image information in the Adobe RGB space.

tends to yield brighter and snappier colors. There's nothing wrong with either setup, per se, but if you want the most potential from your images *and* you work with color management in your computer, then Adobe RGB is probably the best choice. (There's also a derivative of sRGB called Landscape sRGB, which is an even more compressed color space and yields even richer color renditions right from the camera.)

Hue

Simply stated, *hue* is the color you see (and indicate by name), such as yellow, green, or pink. But there are, as mentioned, millions of possible colors. Colors scientists use the color coordinates in the 3-D color model to identify colors, while fashion designers might use Pantone color numbers.

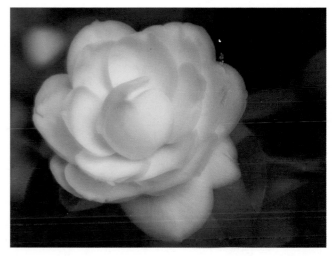

When you hear the word *rose*, so many images can pop into your head. What's the correct color for that rose? Is there just one? Or, is it all open to interpretation and to how you see it in your mind? What you might begin with is hue, or the color of that rose. Isn't a rose red or pink? . . .

. . . Well, no, a rose can be yellow. This isn't a different rose than the one to the left—I just swapped out the red for yellow, a very simple task in software, which points out the changeability of pixel addresses and how digital images have no dyes or densities, just codes.

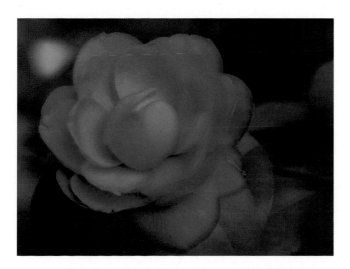

But, can a rose be blue? It's easily done in digital by, once again, changing the pixel codes. And it's not like you have to learn to write code; it's a matter of learning a few simple tools in an image-processing program and making changes in what you see on the monitor as you work.

Saturation (Color Richness)

Think of a wall that's freshly painted, and then think of that wall six months later, after getting hit by direct sunlight every day. The fresh paint will be more saturated than the six-month-old paint. Saturation is the vividness of color, or the depth of the color visual experience.

Different colors seem to respond to higher saturation levels with more or less intensity; reds, oranges, and similar high-frequency colors tend to become extremely "hot," or vivid, at least more so than the lower-frequency colors, such as blues and greens. Blues and greens can have their own vividness, as well, but this is often enhanced more through software than in camera.

The default saturation of a digital camera image processor might vary depending on the market to which the camera is aimed. Amateur-oriented cameras tend to exhibit more color richness right out of the box, while more pro-oriented models tend to exhibit less, relying on users to set their own desired saturation levels.

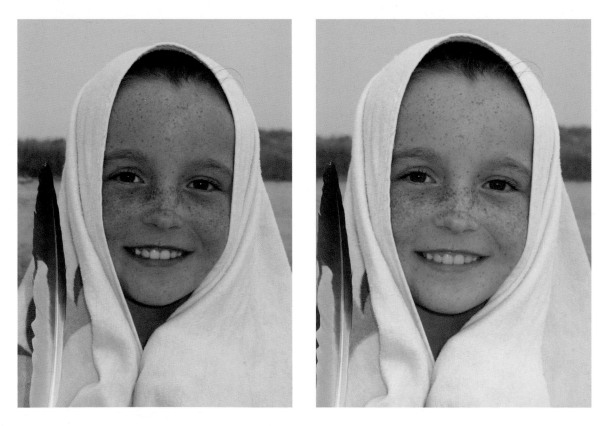

The default setting on the camera that recorded this image was too high in color saturation. While it does yield great color for landscapes and flowers, it's too saturated and contrasty for portraits. There are a number of ways to work around this. Some cameras allow you to set Adobe RGB rather than sRGB, which will yield "flatter" but truer colors. Others have a Portrait Picture Quality mode (as opposed to Portrait exposure mode) that automatically lowers the color saturation and contrast. If neither of these functions is available, then you can simply lower contrast and saturation using the in-camera menu when taking portraits, as was done above right.

Saturation can be high or low. Extremely low saturation, in what would be described as a *desaturated* image file, looks like a black-and-white photograph but is still made up of the RGB components.

PHOTOS: GRACE SCHAUB

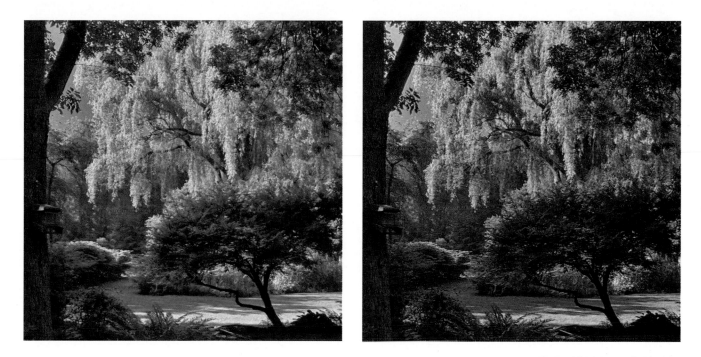

Photographed with normal saturation and contrast, this garden scene has a nice balance of highlight and shadow. It also can be *desaturated* (above right), which means the RGB file configuration has been retained, but the color richness has been diminished in a range from pale to monochrome (just gray, black-and-white tones).
PHOTOS: GRACE SCHAUB

Contrast

You can think of *color contrast* as the *brightness* of a color. Color contrast is certainly influenced by the intensity of illumination that strikes the color (as are all color subjects), but it is also an integral part of a color's identifying code or pixel address. Think of color contrast as a tint or shade of a certain color, as if you're mixing various amounts of white, gray, or black with a pure hue.

Contrast was modified in software after exposure by lightening the original color (above left) to yield the version to the right.

White Balance

The term *white balance*, borrowed from the world of videography, is used to define the influence of the ambient or prevailing light on all colors in the scene. Implicit in that definition is a direction for "correcting" that color, or making it *light-source neutral*, at least as seen by the adaptive eye.

When we look at subjects under different light sources, we tend to take that light source into account and balance the color we see so that, for example, a white sheet of paper will look white both in daylight and under room lights. But the default of many sensors may be set to record color as if it is illuminated by daylight. Thus, that white paper under room lighting will look amber, due to the difference in blue content in lightbulbs and average, sunny daylight.

Sophisticated image-processing systems can get close to an adaptive state of color "perception" in their Auto white balance mode, but they usually need some correction or rebalancing by the photographer. That's where white balance controls come into play. They flood the image-processing information with color codes that shift the color balance to correspond with the prevailing light source.

In the example of the white paper used before, shifting to Tungsten white balance actually adds blue to the image during processing, making up for the deficiency of blue in the room lightbulbs. This is easily seen by choosing a Tungsten white balance and shooting in daylight—the scene will be cast in blue light.

Many of the image-recording options in your digital camera are geared to delivering correct or simply "good" color. Keep in mind that in digital photography color can be as subjective (subject to mood and artistic ends) or as objective (close to neutral or "true," measured color) as desired. Color is affected by many other settings in addition to the more obvious saturation and white balance. Sharpness, contrast, and tone curve settings can have an equal effect, as can more advanced settings such as tint and color temperature controls.

White balance settings deal with the influence of the prevailing light on the scene. They can be used to "neutralize" the effect of the light—that is, match what our adaptive eyes see—or to influence the color for a more creative effect. The yellow color in the sky in the far left image matches what my eye saw and is a result of using the Auto white balance setting. The interpretation at near left reflects the camera's Tungsten white balance setting, normally used for shooting under incandescent light but used here to add blue to the scene and a graduated blue-to-yellow sky.

I made this shot inside a market in Seattle using the Fluorescent white balance setting, which yielded a fairly true color rendition under what is usually a very difficult and unpredictable light source.

Photographed late in the day, this Florida roadside scene (left) emulates the color of the prevailing light but doesn't seem to carry the right mood. Switching to the Shady white balance setting gives the scene a warmer glow that seems to match the scene better (below).

How It Works

There are certain standards as to what constitutes "good" color, and most successful digital camera makers incorporate those standards into their image processors and sensors. If you were to take the camera right out of the box and start shooting on Auto mode, you would have a good idea of what those settings are. But those settings, the defaults, are simply an opinion—albeit a highly sophisticated one—when it comes to what you want your colors to look like.

The colors and their characteristics—hue, saturation, and contrast—are defined by codes and addresses within each individual pixel site. These addresses are mutable at the point of exposure and processing—with camera menu adjustments and options—and later in software. The changes can be subtle, with a slight tint of one color being all that's changed, or "global," with an entire image washed in a certain color or even entirely stripped of the color record.

Try It

Set up a series of pictures that includes a portrait and a landscape or flower made in daylight. Make another set of images under room light. To see how color can be changed, work with the easiest color control on your camera—white balance. Most cameras allow you to change white balance with a push button and toggle on the camera body, rather than requiring a menu choice. On each image, make one photograph at the default setting (Auto) and one with a shift in white balance—any change will do. Compare the results, and note how each white balance setting affects the mood of the image.

Advanced Option

Shoot an image in raw format, and open it in a raw file converter. Use as many of the color controls as you can to see the color options within the recorded image. Check on color space, white balance, tint, hue, saturation, and so on. Keep in mind that these controls are just a small part of what you can do to affect the color later in even more sophisticated image-processing software.

Contrast

Contrast is the relationship between light and dark in a scene and how those visual tones or shades create an overall visual impression. Contrast is one of the strongest elements in visual expression and can be used to imbue a subject with ethereal light or a stark realism. Contrast can also make a subject stand out or become obscured, or it can make you notice line and form or just see masses of light and color.

Contrast cannot be removed from the context or relationship of one area to another within a frame, nor can it be isolated as one pixel without referring to another. Even when you sharpen an image in software (see page 104), you are actually raising the contrast of the "edge" of the pixel and not "sharpening" the entire pixel or the entire picture.

Contrast is highly dependent on the illumination under which you photograph. A "point" light source, such as a spotlight or the sun on a clear winter day, will always yield higher contrast. Conversely, photograph a subject under an overcast sky, when the light source is more diffused, and lower contrast will result.

The angle and direction of the light source vis à vis the subject will also have a strong impact on contrast. If you photograph with the sun behind your shoulder, you'll always have lower contrast than if you place the subject between you and the light source.

Contrast in the abstract (and often in photography) can be thought of as a scale of gray tones, from bright white to pitch black. *High contrast* would mean that the scale is compressed, that many of those middle tones would be forced toward either the black or white end of the scale. *Normal contrast* would display a broad range of those middle tones, while *low contrast* would mean that the tones recorded sit within a limited range of that broader scale.

Contrast has a profound effect on perception. Going to extremes can reveal just how much effect contrast has on both subject matter and your interpretation of it. Think of contrast first as the lighting conditions under which you photograph, and consider how to best capture and control it. Then, see it as a facet of an image that serves as a major foundation of how that subject is perceived.

Although light is never "normal" but always special, photographically speaking, *normal contrast* refers to lighting conditions that result in images showing a relatively full range of brightness and tonal values, from deep black through bright white. When this normal contrast is represented by grayscale bars, you'll see a rich range of tonal values from black to white or indicating shadow to highlight values (with the white end of that spectrum falling to the right).

High-contrast images compress the gray tones, moving black and white closer together and suppressing the shades of gray. When compared to the normal-contrast scale, the high-contrast scale displays fewer shades of gray when going from deep black to bright white.

Low contrast expands one region or section of the grayscale. It can occur in both dim and bright light. It is the range of values, rather than there being light or dark, that defines a low-contrast condition—and that range is narrow.

Contrast is very important to visual expression. Fortunately, digital photography allows for a near-infinite range of contrast renditions, with manipulation available either in camera or, for even greater nuance and control, in software after exposure.

Of course, scene contrast is most important, as it is often what inspires us to make the picture. In most cases, digital technology allows us to match and even enhance that "realistic" contrast. If scene contrast is poor, or a poor exposure doesn't allow for the proper recording of contrast, software can often "rescue" the image, although this rarely yields quality equal to that which proper initial exposure and settings will provide.

In general, high scene contrast, while filled with exciting visual potential, also holds the most pitfalls for photographers (film or digital). Much of photographic technique is aimed at harnessing the potential of high contrast light and keeping it under control so that it doesn't get in the way of image effectiveness.

With digital cameras, you work with contrast through exposure, via meter readings, metering patterns, and making judgments about how to meter a scene; through setting image attributes, or character, via menus such as Contrast and Sharpness and, to a certain extent, Saturation; and in software with a very wide variety of controls, including Levels, Curves, Hue/Saturation, and Contrast/Brightness.

The chief difference between working with contrast in the camera and in software is that camera menu changes are global, affecting the entire image, while software controls can be both global and local, affecting only select parts of the image. Software also offers more nuanced and user-controlled settings.

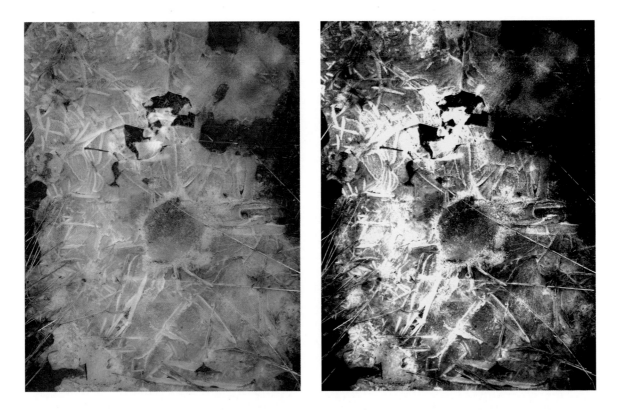

I photographed this frozen bit of ground (above left) under an overcast sky with default camera settings in black-and-white Picture mode. I then gave the image more contrast in software by compressing the tonal values closer together (above right). While high contrast can be a problem, it can also yield images with greater impact.

Getting into Raw

Since raw is, perhaps, the most important format to use when you want to obtain the best image quality, this section focuses on it in more depth than previously covered in the earlier File Formats section. As discussed, when you shoot and then open a raw format image, you first must convert the image from raw to another format—TIFF or JPEG—if you want to print or transmit it. It is in this conversion that you can do both corrective and creative work on the image. Note that most raw converters don't allow you to do selective work on parts of an image; they work on the image in a global, or overall, fashion, although there is some individual color control that can be done. After raw conversion and work, it is always a good idea to finish up the final editing and manipulation in Photoshop or a similar program. The combination of the two will result in the best possible images from your camera.

Keep in mind that when you work on a raw image, you're not changing that image file itself; you can always go back to the original raw shot and work on it again in a different fashion. That's because every raw converter has you use the Save As function on the raw file after the work is done. You can then save the image as a TIFF or JPEG or DNG (digital negative, also .dng), or any other format that's available via the program. The raw original isn't altered, even though it might look changed in your browser. The changed image file is sometimes called a "version," which hints at its nature vis-à-vis the original. All you need do is open it again, click on As Shot, and the original settings and appearance will be active.

To give you a sense of what you can do with raw converters, I'll work with Camera Raw by Adobe. (Note that there are other conversion programs available, and all offer some advantages over others.) Using three images, I'll cover some of the steps done from start to finish, showing various aspects of the power of raw to alter and enhance an image.

The raw conversion screen gives you a host of options. You'll notice that some of the options match what is available in the camera, while others refine the image you recorded. But the chief thing to recognize is that raw file format allows you to work with the image as if you were just recording it. It's an extension of the camera operating system that you can use to enhance or, in fact, override your original camera settings.

This might seem odd. How can you change the camera settings affecting an image after you've made the picture with those settings? But that's just what raw allows you to do. Remember, a digital image isn't recorded in any real way, as it would be on film; it is merely a set of codes assembled together to form a continuous-tone image on a screen or in a print. Those codes can be changed as required or desired. Raw mode allows you to make the most changes in the easiest way; plus, it guides you along the way.

At the time of this printing, Adobe's Camera Raw was the converter in general use. Note that this and other converters will change over time with new versions of software. So, use the following basic control categories as a guide, and apply them to whatever software program you use.

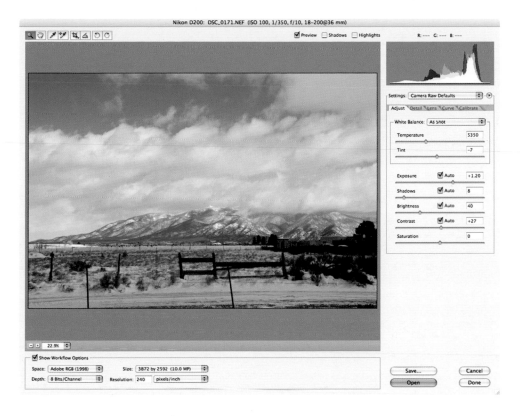

Here's the first screen you see when opening a raw image in Adobe's Camera Raw. I made the image with a Nikon DSLR as an NEF file (Nikon's raw mode).

Space

Beginning at the lower left of the screen above, you'll notice the Space option. Here you have two main choices, although others may be available: Adobe RGB (1998) or sRGB. In general, choose Adobe RGB for printing and the most color options, and choose sRGB if you like more saturated color overall. The best bet is to test, as neither choice is incorrect—they just yield somewhat different color palettes with which you can work.

Depth

Depth refers to the bit depth, or the amount of information in the image file. Some digital cameras can yield up to 16 bits per color channel; some offer 12 and others 8. The greater the bit depth, the more information available from the photograph. This can make a difference with subtle colors, with scenes exhibiting high contrast, and with some very fine detail in images. Note that choosing a higher bit depth increases the size of the file that you will be saving from the image. While there's no question that greater bit depth can yield more information, you should test to see if your photographs and their end use require this, or if all you're actually doing is adding to the amount of the file size for no practical reason.

Size

When you first set up your camera to make an image, you choose the resolution and file compression ratio (for JPEGs) for each shot. However, if you set it to raw mode, then the resolution is always the highest the camera can offer. At the base of the Raw Converter menu in Photoshop sits the Size option. You can click on this and choose whatever pixel dimensions you need (for print, e-mail, and so on). This can save you the trouble of resizing later, as you can always go back to the source (the original image) and resize for another version. You can choose to save the image you shot in raw in various resolution settings. Again, this can come in handy if you want to use the image for e-mail or Web page work, or if you just want a smaller image file duplicate as a record of the raw file. Remember, when you do this, you're not changing the resolution of the original raw file; you're just selecting an option for the version you're saving as the JPEG, TIFF, or whatever image format.

```
    1024 by 1536 (1.6 MP)  –
    1365 by 2048 (2.8 MP)  –
    2048 by 3072 (6.3 MP)  –
  ✓ 2336 by 3504 (8.2 MP)
    2731 by 4096 (11.2 MP) +
    3413 by 5120 (17.5 MP) +
    4096 by 6144 (25.2 MP) +
```

There are numerous pixel dimensions available in the Size option. Match the size with your desired output. Here, an 8.2 megapixel size (an approximate 24MB file size) was chosen to make an 8½ x 11–inch print.

Resolution

When you make a print, or want to save the image for screen viewing on a Web page or as an e-mail attachment, the resolution of the image file comes into play. For screen shots, that resolution is usually 72 ppi (pixels per inch), and for printing the resolution can range from 200 to 300 ppi (or higher). You can set this figure in the raw converter rather than having to reset it later when you output the image.

Preview

In the upper right of the first raw screen on page 43, click on the Preview box to see the result of your changes as you work. Some raw converters will also show you a split screen of the before-and-after versions as you work.

Histogram

In the upper right corner of the raw screen is a three-color histogram of the image, which is a graphic representation of the spread of tonal values (light and dark tones) and colors in the scene. This is a map you can follow as you work, or you can simply let the image on the screen be your guide.

Settings

This feature, just under the histogram, lets you call up settings you've previously made to similar images after naming them and saving them. You can also just stick with the defaults or select the Auto corrections the raw converter assumes you want to make on each image. To save previous settings, just make those settings in the toolbars (which we'll cover next), and then click on the right side arrow and choose Save Settings; to bring those settings back, do the same, and choose Load Settings.

The Adobe program usually makes Auto adjustments to your images in both the browser and the raw converter. In essence, the program is inclined to correct the images for you before you even have a chance to see them as you shot them. This sometimes works fine, but if you'd rather see the images as you shot them first, uncheck all the Auto boxes, and then use the right arrow in this dialog box and choose Save New Camera Raw Defaults. This will eliminate correction in the browser and the check marks on Auto when you open the image in the raw converter.

Once you have set this up, you can begin to play with the look of the image. Note the options you have here. I'll begin with the Adjust tab options. (Again, different raw converters may call these sets of adjustments by various names and have you access them in different ways, but all have the same essential functions.)

Tab 1: Adjust

Below the Settings button is a section of the screen with five tabs offering numerous controls. On the next few pages, I'll cover a few of the adjustments you can make with these various features. Let's start with the controls under the Adjust tab.

White Balance

White balance compensates for the influence of the prevailing light source on the colors in the scene. You can change this from As Shot (which is however you had set it up in the camera) to any other choice you have in your camera white balance. It's best to play with some of the options to find the best match for the image at hand, but if you'd rather not, you can just leave it. The Shade, Flash, and Cloudy white balance settings will add warmth, or a yellow cast, to the image, while Fluorescent and Tungsten will make it cooler, or bluer. You can also modify the color settings with the Temperature and Tint sliders available here.

Tint moves the color on a magenta/green axis, something those who printed color in the darkroom will understand, but Temperature is more of an obscure reference. It refers to the Kelvin scale of color, based on the temperature of a burning object under controlled circumstances. As you move the Temperature slider to the left, the image will gain a bluer cast; a move to the right yields a more yellow cast. In essence, the two sliders are moving the color cast of the image around an axis defined by yellow/red in one direction and purple/green in another. Just about every combination is possible by tweaking these sliders in one direction or another.

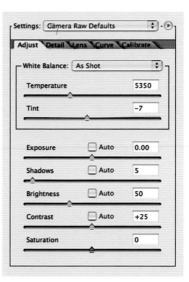

In the first screen back on page 43, the Auto buttons are checked. Here's what the dialog box looks like when you click off the Auto check boxes and choose Save New Camera Raw Defaults.

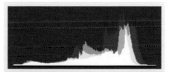
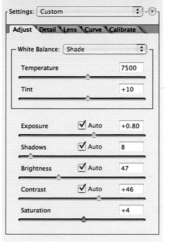

In this dialog box, the only thing that has been changed from the Auto settings supplied by the program is the white balance, which has been set to Shade. This warms up an image considerably.

Exposure

Adjusting the Exposure slider in the raw processing software is akin to setting the exposure compensation dial on your camera when you make the picture. It does seem strange that you can, in essence, correct exposure after it's made, but that's exactly what this setting allows. If a picture seems overexposed, you can dial in a minus setting; if it's underexposed, use the plus settings.

Shadows

The Shadows slider allows you to deepen or lighten the shadow, or darker, areas in the image and works in tandem with the Exposure slider. It makes the adjustments without affecting the brighter areas of the scene.

Brightness

The Brightness slider is another ally of the Exposure slider and handles the overall brightness of the image. You can use this to pump brightness into the image or make it moodier or darker.

This screen shows a correction on a shot that was underexposed by 1 stop.

Contrast

The Contrast slider is just like the contrast setting in your camera menu, which allows you to raise or lower the overall contrast of a scene prior to exposure. This is a much better way to control contrast, as it allows you to do so after exposure, when you can tweak the contrast to the exact setting you want, rather than requiring you to guess what +1 contrast setting in the camera might mean. This is, to me, one of the most important controls in this entire dialog box, and I find myself using it quite often to control harsh or what I consider excessive contrast in an image.

Saturation

Just as your in-camera settings allow you to apply greater or lesser degrees of color saturation to your images, so does the Saturation slider in the raw converter software. This affects overall color saturation.

Here's one image as shot and delivered by the camera (right). I took it with flash at close range, which made the scene rather "hot" and harsh. Compare that to the image as it came out of the raw converter (opposite). While some other attributes were changed slightly, the major adjustment was to the contrast setting and, later in the dialog boxes, the green saturation settings (more on that on page 162).

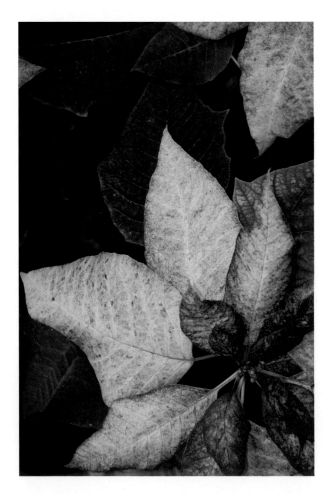

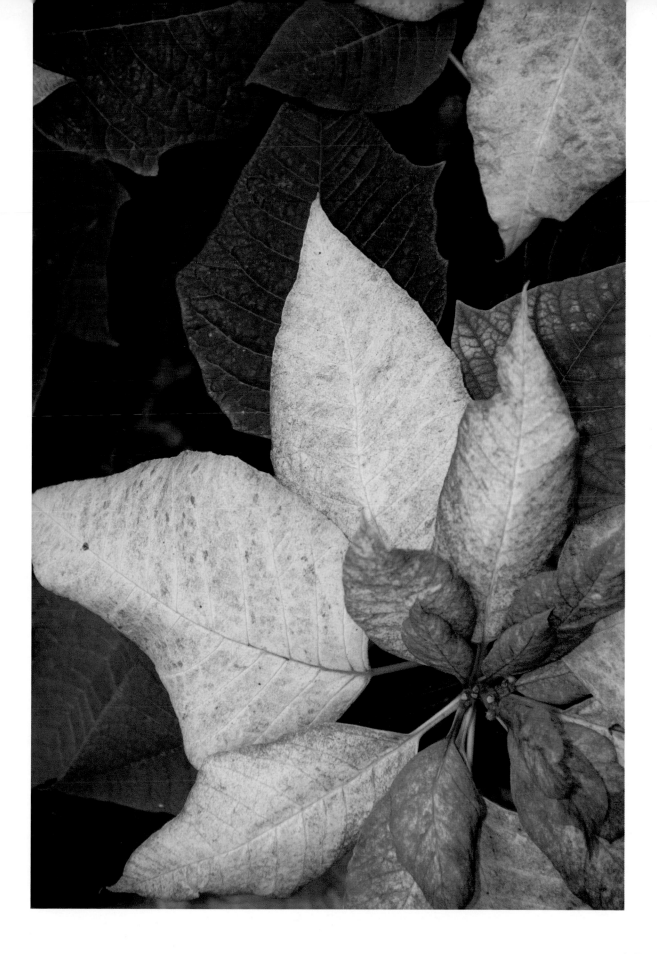

Tab 2: Detail

The details that this tab refers to are the edges and artifacts that might be introduced into an image by the way the camera processes them (or fails to process them). The Sharpness setting refers to how much contrast the program applies to the edge of pixels in your image. More contrast equals a sharper look; note, however, that this will do you no good with a blurry picture.

Most digital cameras apply some sharpening to every image processed in the camera, raw format or not. Early models of some professional-level cameras applied no sharpening, which at times could make the image look "soft" or slightly blurred. That practice has abated for the most part in cameras made after 2005. My advice is to save the sharpening step until you get the image into a full-service editing program and to pass on this adjustment in the raw converter.

The same goes for Luminance Smoothing and Color Noise Reduction. Both deal with the artifacts that can occur when you shoot at a high ISO or use long exposure times to make your image. Noise reduction (NR) can be applied in camera (see page 66) or, more effectively, by opening the image in Photoshop after raw processing or with third-party noise reduction programs, many of which work better than the noise reduction in most raw converters.

The controls under the Detail tab.

THE IDEAL USE FOR A RAW CONVERTER

The start-to-finish process on raw conversion can be as quick or as studied as you like. Just remember to leave some creative time for full-blown image manipulation in a dedicated imaging program later, and consider the raw converter as a foundation for that work.

Tab 3: Lens

The Lens tab features attempt to correct any optical faults owing to the use of certain lenses on your camera. The top sliders afford subtle changes in fringing, which is due to chromatic aberration, when different wavelengths of light (hues) focus at different distances on the sensor, causing some loss of quality around tonal and color borders. Most lenses are highly corrected these days, with coatings that limit this fault, so you probably won't see much of a change with the Fringe sliders.

The Vignetting sliders can be used to eliminate any light falloff from the edge to the center of the frame, usually caused by working with a wide-angle lens at a minimum aperture. More often, I use this to *add* vignetting (darkening of the edges) rather than remove it.

Tab 4: Curve

This tab offers a curve control along with a histogram readout of the tonal distribution of the image. The curve starts out as a line that stretches from the shadow area (lower left) through the midtones through the brighter, highlight (upper right) areas in the screen image. Altering this curve alters the tonal distribution of the image. You can brighten midtones, darken the shadow areas, or suppress bright highlights by changing the shape of the line. Frankly, you're better off doing this in an advanced imaging program than in a raw converter.

Tab 5: Calibrate

The Calibrate tab provides other features that let you control the color, but here you control it more selectively than with White Balance or Saturation. By moving the appropriate slider, you can change the tint and saturation of distinct colors, thus affecting all the other colors through an "adjacency" effect (meaning that the colors adjacent to the one changed color will also now look different because of that change).

The controls under the Lens tab.

The controls under the Curve tab.

The controls under the Calibrate tab.

I brought this raw image into a raw converter by double-clicking on it in the image browser, Photoshop Bridge. This opened it in the Camera Raw workspace. I'll use it here to illustrate a few of the adjustments you can make.

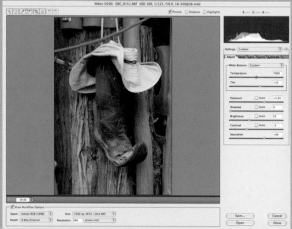

Since the Auto checkboxes were on, the first step was to uncheck those boxes and to see the image in As Shot mode. There were two things I wanted to adjust. Even though the overall image was well exposed, the hat was a bit "hot" (overexposed, thus harsh); also, I wanted to have a warmer rendition of the photo.

Here's the work screen after I made my adjustments. Notice the difference in values and how moving the sliders to the left or the right added the effects I desired. I changed the Temperature and Tint to make it warmer, kept the Exposure and Shadows as they were but dropped the Brightness value, dropped Contrast to lower the values on the burnt-up hat, and increased Saturation to enrich the colors. For a final tweak, I played with the colors a bit more in the Calibrate tab.

Here's the image when I first brought it into the raw converter (As Shot).

And here it is when I finished with it in the raw converter. This process took me about a minute, including consideration of what changes I wanted to make.

How It Works

Images as information means that all the information is malleable. When you photograph with the raw mode, you're limiting the processing that the camera's image processor performs and putting off this processing until after you download the files to your computer. A raw converter mirrors what occurs when you shoot JPEGs or TIFFs with image characteristics in your camera, but it makes the process manual, if you desire, or, at the least, under your full control. The raw file remains as unprocessed information even after you make certain decisions because you always end the process with a Save As command, making a copy or version of the original (which remains unchanged). You can always return to the original to make even further variations and improvements if desired.

Try It

Photograph a series of raw image files, and download them into a raw converter. Access the controls under the various tabs (or wherever they may be in your program), and play around with them. Do this with a portrait, a landscape, and an abstract composition, and get a feel for how each control allows you to vary the look and feel of the images.

Advanced Option

You can make the same changes on a series of images in the raw converter by "batching" them together. Open your browser, and choose six or a dozen raw images to which you want to apply the same changes. Click on any one of the images, and all will open in the raw converter at once, usually as thumbnails. Make the changes you want to the image that appears large on the screen, then select the Save or Open options to move along to the next step.

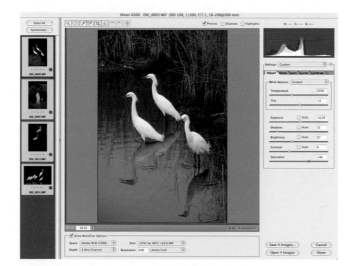

When you make the same changes to a batch of images, one image opens in the main window of the screen and the others appear as thumbnails. After you make the desired changes to the large image, you can apply the same changes to the remaining shots.

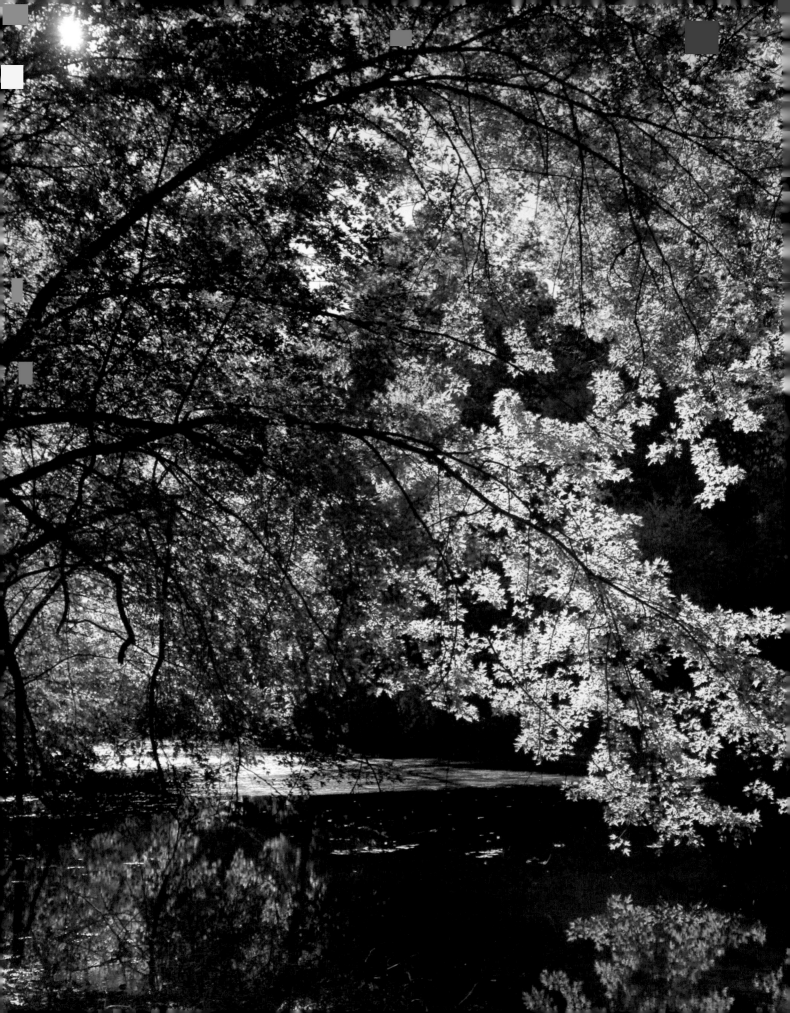

Part Two

IN-CAMERA CONTROLS

□□□□□□□□□□□□□□□□□□□■

A Quick Camera Tour

All digital SLRs resemble the body build of film SLRs, albeit with considerably more buttons and dials. The same light path is used, as are the same lens mounts, for the same brands. Just because a camera has a digital sensor doesn't mean that it can alter the principles of photography. Digital images are still subject to similar rules about exposure, shutter speed, depth of field, and focusing. So, the photographic side of things, if you will, is primarily the same in digital and film SLRs. The difference comes after you press the shutter release and the light passes the exit pupil of the lens. That's when electrical charge and signals and microprocessors and binary code take over.

To become familiar with a digital SLR, let's take a brief tour using two camera models: a Nikon and a Canon. Their design and approach is similar to many other brands and models. Any difference is in placement of controls, terminology, and certain proprietary—and some would say idiosyncratic—features and functions. If you don't have one of these models, however, the tour will be generic enough to apply to your own camera. So, please keep your own instruction book nearby.

Before you read this section, it's best to get an overall feel for your camera. There are usually two ways to change functions and programming within the camera. One is via the camera body itself, which is best for those functions that you use most commonly; the other is via the camera's internal menu, which you open up on the LCD (liquid crystal display) by pushing the Menu button on your camera. Often, making changes from the camera body doesn't require that you open the LCD menu; rather, these are shown either in the camera viewfinder and/or on the LED (light-emitting diode) panel on the camera back or top.

Both menu changes and changes made from the body are controlled by one or two dials or toggles. These dials are sometimes called the main Command dial or toggle and the sub-Command dial or selector. It can sometimes be confusing as to which dial changes which functions, and in fact, there are so many options available that camera makers often assign one set of changes to the main dial and the other to the sub-Command dial. The only way to get comfortable with this is by reading the instruction book and practicing with the camera as you go.

There are so many functions and sub-menu items available in these cameras that to discuss them in the context of this book would be impossible. Instead, I'll focus on the buttons and dials for the most common functions and features of the majority of digital SLRs. These controls include exposure, focusing, choosing file format and resolution, changing ISO and image characteristics, and playback and information displays.

To start a basic camera tour, let's look at the camera body. This is the back of a Canon. The main Command dial on this model is on the lower right of the back of the camera body. There's another knurled ring (slightly out of view on the upper right) that can also change the programming on the cameras as well as be used to view images in Playback.
PHOTO COURTESY CANON USA

The LED (light-emitting diode) panel is a guide to settings, and you use it as you choose options and turn dials to change settings. The LED on this Nikon lets you know that, in this example, the camera is in P (Program) exposure mode, the shutter speed is 1/100 sec., and the aperture is *f*/5. In addition, the warning beep is on and the battery is fresh. On the lower line, you can see that the format is raw and JPEG Fine, the focusing pattern is Dynamic Area AF, the white balance is Auto, we're in shooting memory bank A, and there are 44 frames left on this memory card at this resolution and format setting.

PHOTO COURTESY NIKON USA

This Canon LED indicates the following settings: Auto white balance, shutter speed of 1/8000 sec., aperture of *f*/5.6, 55 frames remaining on the card at this resolution and format setting, raw format, evaluative metering mode, and one-shot (single shot per shutter release). It also shows that there's no exposure compensation set (the +/- scale).

PHOTO COURTESY CANON USA

This is the camera front without the lens. To remove the lens, push the lens-release button (the large button to the side of the lens mount). When you attach a lens, you align the red dot on the lens mount with a corresponding dot on the lens and turn until you hear a click. Inside the collar of the lens mount sits a series of pins. These are the contact points between the lens and the camera body over which information is passed back and forth. The camera is the source for exposure information and aperture settings, while the lens sends back information on the focal length and the actual aperture set. The rectangle at the center is where the sensor (the light-recording element within the camera) sits. Note that the sensor is covered with a protective sheeting to prevent direct contact with it. Be careful with the sensor. If you change lenses, always shield the interior of the camera from dust. Never change lenses with the camera on, as the charged sensor will attract dust like a magnet. Note also the small button below the lens-release button; that's the depth-of-field preview button discussed on page 58.

PHOTO COURTESY CANON USA

Exposure Controls

To get the most out of the sophisticated exposure system in your camera you should know how to choose the exposure mode and metering pattern and how to lock exposure. Exposure modes affect how the camera's exposure system translates the light in photographic terms to meet your creative needs. Metering patterns define how the light is read by the system. Locking exposure is a key technique to making good exposures in high-contrast or difficult lighting conditions.

One of the most important parts of setting up exposure is choosing ISO (the sensitivity of your sensor to light). In general, the lowest ISO setting your camera offers yields the best image quality, but higher ISO settings certainly come in handy for action, very great depth of field, or low-light photography. Most cameras allow you to quickly change the ISO via controls on the camera body.

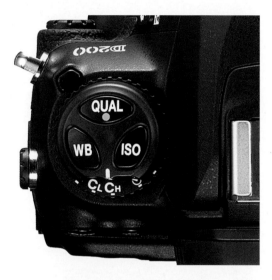

To change ISO on this Nikon, press the ISO button and turn the Command dial to select the required sensitivity. The changes show up in the LED atop the camera (shown at the top of page 55).
PHOTO COURTESY NIKON USA

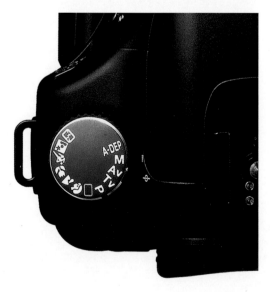

The Canon exposure mode dial shown here contains numerous modes. Each one determines how the exposure will be balanced between aperture and shutter speed once the exposure reading is made. In addition, some of these modes set certain image characteristics, such as saturation or sharpness. Starting at about two o'clock and moving clockwise, the modes go as follows: A-DEP is unique to Canon cameras (it's for when after selecting a focusing distance for a foreground subject and lightly tapping the shutter release, you do the same with a subject further away, and then the system determines the proper f-stop to attain a depth of field that makes both subjects sharp). M is for manual (when you want to select aperture and shutter speed, or want to quickly override the camera's metering recommendations). AV is a Canon abbreviation for Aperture Priority mode (when you pick the aperture and the camera picks a shutter speed). TV is for time value or Shutter Priority (you pick the shutter speed and the camera picks an aperture). P is for Program mode (when the camera system picks both

aperture and shutter speed, although you can move these values around in relation to each other). Program is for complete automation, although you can still affect other parts of the exposure or image characteristics. The Green Zone is fully automatic; you can't override anything, and the camera system takes control of every aspect of shooting.

After the Green Zone, the next set of modes are usually called Scene modes. These are inherited from point-and-shoot digital cameras, and they affect aperture and shutter speed, as well as the image characteristics that are recorded when the exposure is made. Portrait mode sets a fairly large aperture—and in some cameras also lowers the contrast and sharpness, and might even add some warmth to the color. Landscape mode (often indicated by a mountain) reduces the aperture for greater depth of field and usually increases color saturation. Macro mode (often indicated by a flower) sets a fairly large aperture. Sports mode sets a fast shutter speed given the light and ISO you have set, although on some cameras the ISO might be boosted to attain even faster shutter speeds. Night Portrait mode (often a little star and figure in a box) activates the flash for the foreground and keeps the shutter open (slow sync) longer than flash sync speed to bring more ambient light into the background. Flash Off mode prevents the flash from firing regardless of the need for it. Use this when flash is prohibited (use a high ISO instead) or its use would be discourteous.

PHOTO COURTESY CANON USA

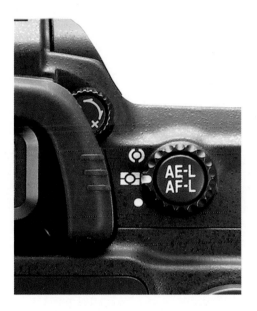

The metering pattern selection dial on this Nikon body makes it easy to select the pattern that matches the lighting at hand. The middle pattern (the circle within a rectangle) is Nikon's matrix metering, a very sophisticated system that separates the picture into numerous zones and then, after examining the light in those various parts, makes an exposure decision based on a preprogrammed set of solutions. This might be called Evaluative, Intelligent, or something similar in other brands. It's quite effective for 85 percent of your pictures. The circle within a cicle is center-weighted averaging (CWA) metering. This pattern makes most of its exposure decision based on light gathered from the center of the viewfinder (an oval shape inside the rectangular viewfinder). It's very effective for backlit subjects that fall in their own shadow or for very high-contrast scenes for which you have to be careful with the highlight reading. The single dot is for spot reading. This takes light information only from a small portion right in the center of the viewfinder. You can switch that portion to various focusing targets (other than the center) in most cameras if desired. You use this when you want to base exposure on a very small section of the frame.

The large AE-L/AF-L button handles autoexposure lock and autofocus lock. The exposure part of its function is that you lock your reading (keeping the same settings) even if you change the framing of the scene or if the light changes. This is a very important exposure control for getting good exposures in contrasty lighting conditions. The Canon model has the AE-L feature (on the upper right of the camera back), as well, designated by a star symbol (see page 54). Note that you can use AE-L and AF-L together or separately.

PHOTO COURTESY NIKON USA

Focusing

Given the prevalence of autofocus (AF), there are a number of key controls on the camera body and on the lens. Most AF lenses come with a manual/auto switch. If you find that the lens cannot find focus (such as on low-contrast subjects), then simply switch to manual focus by moving the switch to the M setting. The camera body is where the focusing pattern and focusing mode controls are. You also can use buttons on the camera for focus lock to maintain focus on a subject even if you change the framing after you make the focusing decision.

You can see the Nikon AE-L/AF-L button on page 57. As mentioned previously, you can separate the autofocus lock function from the autoexposure lock function (via the menu), which I suggest. You can also lock focus in a number of camera models by maintaining slight pressure on the shutter release button as you change framing.

The focusing mode determines how autofocus and shutter release interact. On the Canon shown at the bottom of the facing page, you press the AF button atop the camera and turn the smaller command dial to make changes. There are three general choices: AF-C, AF-S, and Manual. Manual focus might be set on the lens itself. AF-S (single) means that you can only shoot if the camera has attained and confirmed focus, usually indicated by a confirmation light within the viewfinder or a beep (which you can, thankfully, turn off). AF-C means that the camera will shoot even if you have not confirmed focus; this is a mode best used for action photography. It might be best to always shoot in AF-S, but when that's impossible because of the subject, then AF-C is the mode to choose. Manual focus is for when autofocus simply will not work (i.e., the lens starts searching too much for focus or "grabs" onto subjects within a crowded frame that you don't want as the primary focus).

Last but not least, there's the depth-of-field preview button, an essential part of focusing control. When you view photographs through the viewfinder you're looking at them at the lens's maximum aperture, which lets the most light through so that you can best compose and consider your photo. When you photograph, the lens stops down to the picture-taking aperture, which is usually narrower than the maximum aperture and thus lets in less light. When you engage the depth-of-field preview button, you can see the scene with that picture-taking aperture and can view what will be sharp and unsharp in the scene prior to making the actual exposure. This is an invaluable tool. Look in your camera manual for the location of this feature on your model.

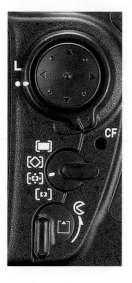

Camera models vary in their autofocus pattern offerings depending on the intended camera user (i.e., professionals vs. amateurs). Generally, the pro models will have more elaborate choices. The focusing pattern switch on this Nikon has four choices. (The focusing patterns are modified by how you set up the focusing area targets within the camera itself; on some cameras, this can be handled by internal menus, and on others, it's done right from the camera body.) Starting at the bottom, there's what Nikon dubs single-area AF; this pinpoints only one focusing point within the viewfinder and is best for still life photography or for when you're making the center point the focusing-acquisition area. Above that is Nikon's dynamic area autofocus; this is good for moving subjects because it will maintain focus on a single subject even if that subject strays from the initial focusing point or points. (This is perfect for sports or photographing active children.) The symbol above that is called group dynamic AF, which allows you to set a broader area (rather than a single point) for focus. *Group* indicates that a cluster of points are used rather than only one. The topmost symbol is what Nikon calls "dynamic area AF with closest subject priority," which simply means the system will focus on whatever subject within the entire area of the focusing points is closest to the camera; you don't get to choose anything here.
PHOTO COURTESY NIKON USA

Drive Mode

The drive mode indicates how many shots per shutter release will be made. Single is one shot per release; multiple means that the camera will keep shooting as long as you keep pressure on the release. There are two factors that determine what you will be capturing: the framing rate and the burst rate. Framing rate means how many shots per second the camera can make; burst rate means how many shots can be made within a continuous sequence and is limited by the size of the file, the buffer (storage area within the camera that queues up the images for processing), and the framing rate of the camera shutter. There might be two or more continuous modes available: low speed and high speed, the latter offering faster rates but often at the expense of overall resolution.

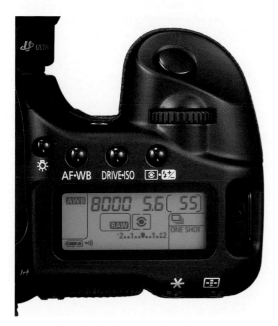

On this camera, drive mode is changed by pushing down the Drive-ISO button and turning one of the Command dials. The changes show up in the LED panel. You might also access the self-timer (which delays shutter firing a few seconds from shutter release) from this button. Note also the AF-WB button, through which AF modes are changed.
PHOTO COURTESY CANON USA

Quality: Format and Resolution

Digital technology offers so many options that you'll need a good deal of time—and some fairly esoteric shooting situations—to use them all. But, there are a number of functions that are essential to set up prior to making photos. These digital options are chosen very much like the photographic options: either from controls on the camera body or via the menu. As with photographic options, dials and buttons activate the selections you can make, with the readout being in the LCD, LED, or camera viewfinder.

Perhaps the most important digital decision to make prior to making pictures is what most manufacturers dub the *quality*, or file format and image resolution. You can choose between raw and JPEG, JPEG in various resolutions, or even raw + JPEG (which makes simultaneous raw and JPEG images with one press of the shutter release).

The Nikon has the Qual (quality) button on the top left of the camera (see top image on page 56). Press the Qual button, and the choices come up in the LED. You scroll through and choose via the Command dial; it's a quick and easy method.

On some cameras, you have to access this change through the menu. On this Canon (left), you press the Menu button, and the first menu set that comes up is the camera or recording menu, with the first option being Quality. You make choices via the Command dial and the set button at its center.

PHOTO COURTESY CANON USA

Image Characteristics

There are numerous options when it comes to image processing within the camera, including changing contrast, color tone and balance, color saturation, color cast (white balance), and even changing the photo from color to black and white. These choices can be made via the menu or from some controls on the camera body.

SHOOTING MENU	
Shooting Menu Bank	A
Menu Reset	--
Folders	100
File Naming	DSC
Optimize Image	
Color Space	Adobe
Image Quality	FINE

In the Nikon, shown here, you access Optimize Image and Image Quality under the Shooting Menu, usually indicated by a camera icon. To access the image characteristic controls in the Canon, you press the Menu button and scroll down to the Picture Styles options. Other camera manufacturers have their pet names for these options, as well.

Playback

Once you've made your photographs, you'll want to review them to decide whether to keep or delete them. This is easily done by pressing the Playback arrow on the camera body. You can see this button on the Canon opposite (top image); it's the one with the arrow in the rectangle. This feature will be in a prominent position on all camera bodies. You can also modify the LCD screen to zoom in on parts of the image being reviewed and scroll around it to check focus, facial expressions, and so on. This zoom function is often accessed through buttons with magnifier symbols that have plus and minus signs in them.

With the Playback function, you can also get all your exposure information, see a histogram of the image, and get overexposure warnings, the latter being a very useful tool. Of course, one function of Playback is to help you edit as you shoot to both free up space on your memory card and save you from looking at your mistakes again later. To do this, bring an image up on the screen and push the button next to the garbage can symbol on your camera back. To avoid accidental deletions, many systems make this a two-step process that asks you to confirm that you want to eliminate the picture.

On this Canon, the zoom in and zoom out Playback buttons are on the upper right corner of the camera back.
PHOTO COURTESY CANON USA

How It Works

Digital cameras are essentially microprocessors with a lens. Their operating systems are defined by photographic principles, but within those principles are a vast array of options and customized controls. Every aspect of making photographs can be altered and refined to match your working, and even aesthetic, desires and needs. In essence, these cameras are clay awaiting molding by your hand and eye. Fortunately, the codes you embed are all done with an interface that uses photographic terminology and practice as their translator.

Try It

The best way to learn about all the options with your camera is to tackle one aspect at a time, and then to hone the programming to the most comfortable and rewarding sets. Throughout this section, we'll explore different aspects of photography and how to put them into effect with a digital camera. Whether it's controlling color, setting exposure, or reviewing images in playback, use each exercise to familiarize yourself with your camera and with how you can get the most out of it.

Advanced Option

Scroll through the menus and choose three or four items for a particular type of shooting scenario, such as portraits, sports, or landscapes. Find and set the menu items, and create a memory bank for each one. Then, go into the field and photograph that subject matter with the banked settings, and see how your choices affect the way you work. Refine the choices as you learn the advantages or disadvantages of each setup.

ISO: Light Sensitivity

ISO stands for the International Organization for Standardization. It is a group that sets international measurement standards for various industries, including photography. Why ISO and not IOS? Since the organization's name would have different abbreviations in different languages, the organization decided to use ISO (derived from the Greek *isos*, meaning equal) as the short form of its name.

Every digital camera sensor (and all film) has an ISO number, which identifies the sensitivity to light. ISO numbers generally range from 100 to 3200; each time you double the number, you double the sensitivity to light, or gain 1 stop in relation to aperture and shutter speed values. It all works together. For example, at ISO 100, say, an exposure is *f*/8 for 1/60 sec. Change the ISO to 200 and you gain an extra stop and would be able to photograph the same scene at *f*/8 for 1/125 sec. or at *f*/11 for 1/60 sec.

ISO is one of the constants in the light metering equation. The other is what's known as *scene brightness*, or the light in the scene before you. The arbiters of light coming into your camera are the aperture (lens opening) and shutter speed (duration of exposure). Change the ISO, and the aperture and/or shutter speed values change.

Cameras have a default, or factory-set, ISO on the sensor. This generally ranges from ISO 100 to 200, although some have lower ISO options. A number of cameras also have what's called Auto ISO, which means that the light metering system will trigger an automatic increase of the ISO when it detects low-light conditions. You usually change the ISO via the recording menu, but a number of cameras also have ISO buttons on the camera body that evoke the ISO menu on the LED or LCD. The ISO can be raised or lowered via command dials or toggle buttons.

ISO, APERTURE & SHUTTER SPEED

The two charts below show how ISO affects aperture and shutter speed values for one given lighting condition. Note how as the ISO increases, the aperture can be made smaller or the shutter speed can be made faster. So, in the first chart, increasing the ISO allows for smaller apertures at a handholdable shutter speed for increased depth of field; in the second, it achieves a faster shutter speed.

You generally raise ISO speed when you want to shoot with the available light (without flash) in low light and need to achieve a shutter speed that will prevent camera shake. This is usually around 1/60 sec., although with longer lenses you should try for at least 1/125 or 1/250 sec. Image stabilization (IS) lenses and camera systems can help, but even those might require higher ISO settings to keep the image steady.

ISO	Aperture	Shutter Speed
100	f/5.6	1/60 sec.
200	f/8	1/60 sec.
400	f/11	1/60 sec.
800	f/16	1/60 sec.
1600	f/22	1/60 sec.

ISO	Aperture	Shutter Speed
100	f/5.6	1/60 sec.
200	f/5.6	1/125 sec.
400	f/5.6	1/250 sec.
800	f/5.6	1/500 sec.
1600	f/5.6	1/1000 sec.

The top image is a typical example of when raising ISO comes in handy: photographing inside a church without flash. The ISO on this shot was set to 1600, which allowed for an exposure of *f*/4 for 1/125 sec.

On the other side of the coin, this night shot (directly above) in Las Vegas was made at ISO 800, with an exposure of *f*/5.6 for 1/125 sec. I didn't use flash for either image.

While you can go to ISO 1600 on most cameras, in general, low-light scenes can benefit from lesser ISO changes, such as this photo made in the deep woods on an overcast day. I raised the ISO to 400 to allow for shooting without flash at a steady, handholdable shutter speed. This speed hardly shows any noise or ill effects on the image.

How It Works

The default, or factory-set, ISO of the sensor is its *native* speed, or sensitivity. The sensitivity is raised by applying a "gain," or additional electrical charge across the sensor field. These hyped-up photo sites are more light sensitive, but they also may be "noisier," or show some artifacts, and the image itself may exhibit higher contrast. Some systems handle this noise better than others, with noise reduction filters as part of the image processing within the camera. These filters do reduce the noise; however, they tend to slow down image processing a bit and can decrease image sharpness. You can also do noise reduction via specialty software after downloading an image to your computer.

Raising ISO isn't just for working in low light. In this photograph of water rushing down a stream during the spring thaw, the fastest shutter speed at the camera's default (or native) ISO, even in fairly bright light, was 1/250 sec. at the desired f/8 aperture setting. I raised the ISO from 100 to 400, adding 2 stops of shutter speed for a final exposure of f/8 at 1/1000 sec. that was fast enough to "freeze" the motion of the rushing water.

Try It

Photograph an interior scene at your camera's native ISO without flash, and note the shutter speed and results. If the photo exhibits camera shake (a blur from motion, not lack of sharp focus), find the higher ISO that will allow you to shoot at a handholdable shutter speed without flash. Set the ISO in 1-stop increments until you reach the highest ISO setting attainable with your camera. Note if and when objectionable noise appears in the picture.

Advanced Option

Use ISO as a way to gain higher shutter speeds and smaller aperture settings. Set the camera on Program exposure mode, and take an exposure reading of a scene. Then, start raising ISO one step at a time, and note the change that occurs in aperture and/or shutter speed settings. Do the same in Aperture and Shutter Priority exposure modes. This will show you how your camera responds in its programming to ISO changes, and should allow you to understand how and when to apply those changes when working in the field.

Noise Reduction

Noise in a digital image is like poor TV reception. It looks like a form of color static, which creates "fringes," or visual shards, around certain colors, and looks very granular, like very high-speed films of the past. Noise results from shooting at a high ISO (800 and higher in better cameras, sometimes 400 and higher with less-expensive cameras). It can also result from long exposure times, such as 1 second or longer.

Manufacturers realize that noise occurs in some situations, so they have built noise reduction (NR) algorithms into their in-camera image processors. Some cameras automatically set this into motion if images are made at ISO 800 and above, and you must turn off the setting as an option. Others make NR part of the image processing only when you choose it as an option.

The NR software has a tendency to "smooth" the image, in an attempt to get rid of the granular look. Some programs do this selectively by analyzing the image (detecting noise in the signal) and eliminating only the most obvious manifestation of noise, while others simply smooth the entire image. If too much noise reduction is applied (in the camera or later with filters in specific software or applications), the image, or sections, can attain a plastic, overdone look. That's why some cameras have a Low and High NR setting. You can also do selective noise reduction work in software, and most raw processors have a NR filter option, with varying degrees of effect available.

I made the photo above right after sunset with the camera set at ISO 1600. Exposure was *f*/5.6 for 1/15 sec. The high ISO and low light is a clue that noise reduction might be of benefit.

Noise is very apparent in the dark sky in the top image on the facing page—made more so by increasing scene contrast in software. This cropped portion is from an image made with Noise Reduction software turned off.

The difference in noise is dramatic here in the bottom image opposite. I made this image with the in-camera Noise Reduction filter turned to High. This reduction in noise takes place right after the image is exposed. It might take a bit longer to process the image in camera, but the difference in image quality usually makes it worthwhile.

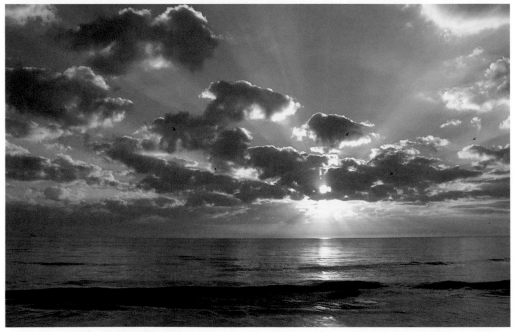

Noise can show up in high-contrast scenes, as well, or even in open areas of like pixels. I shot the top image at ISO 400, usually a fairly low-noise rating, but noise shows up in areas of the blue sky. It might not be apparent in a small image, but when the image is cropped and enlarged, the noise is apparent. It shows up as darker specks among what should be a continuous, smooth blue in the sky (bottom image).

The noise has been "smoothed" in the image opposite, although as a result, the image looks a bit unreal, or idealized. This is a result of after-exposure application of a Noise Reduction software filter. Be aware of the line between eliminating noise and creating a plastic veneer on an image.

How It Works

A sensor has what's called a *native* speed, its sensitivity to light. Most sensors have either an ISO 100 or 200 native speed. When you increase the ISO setting, or enhance the sensor's light sensitivity, you're applying "gain," or extra electrical charge across the sensor, which increases the static, or noise. Noise reduction filters actually work to enhance the signal-to-noise ratio so that this static, or visual grain, is reduced. Noise can result from setting a high ISO and from long exposure times. Some cameras exhibit more noise than others at equivalent ISO settings. This may be simply a matter of better NR filtration algorithms.

Try It

Photograph in low light with a high ISO without setting NR filtration (if necessary, disable the default NR filtration to do this). Then, make the same photograph with NR on. If there are two NR settings, Low and High, try the same image with both. Crop in on the area of highest noise in the "off" image, and compare with the same area in the NR "on" image or images.

Advanced Option

If your camera has an Auto NR function, find out the settings that will activate it. For example, NR may automatically kick in at any setting above ISO 400, or at an exposure time of 1 second or longer. This may help you avoid setting and resetting NR as you shoot. In raw mode, shoot without setting NR (or with NR disabled), and then apply NR in raw processing software. Compare this with NR in camera.

White Balance

There are a number of factors that affect how color is recorded in a scene, including, of course, the hues of the subject and the brightness of the light source, and also the color cast of the light source. Our eyes are adaptive, which means that we respond rapidly to levels of light and changes in the prevailing light. If the light source is very low, we respond by dropping away color and seeing in an essentially monochrome spectrum. If the prevailing light source is extremely dominant, such as just blue or yellow light, then of course, we see things bathed in that light. But if the light source is merely influenced by a prevailing light, or lacks certain colors of the full spectrum, we tend to "fill in" and balance the colors that we see to a more normal spectrum. That's in the real world.

Sensors don't "see" color. They are, in fact, monochrome (black and white) and only record color because of color filters that are placed over them. These filters sort the light as it comes through into red, green, and blue components, and each photo site reacts to the intensity of each color with a signal that eventually becomes a code. Sensors don't respond, and adapt, to color changes—they merely record the color as it lands on them in various brightness and hue values. How the color is adapted or changed from there is dependent on how color is managed by you in the camera and later in software, and by the camera's image processor.

One of the ways you manage color in a digital camera is through the white balance settings. This doesn't alter the color of the subjects themselves, but rather the influence of the prevailing light source. In most cases, this is a corrective measure, used to eliminate the dominance of one light source. For example, photographs made in shade tend to have a blue cast due to the lack of yellow in the light. To bring in a more natural or balanced (but not necessarily truer) color cast, you program the image processor in the camera to add yellow to the overall color mix by choosing the Shade or Cloudy white balance setting.

Another example would be photographing in an interior lit by incandescent light (regular lightbulbs). Since these bulbs are deficient in blue, you would obtain a more balanced color cast by setting the white balance to Interior, or Incandescent, which adds a blue cast to the prevailing light.

Your camera may have up to seven or eight white balance modes built in, each named to counterbalance the prevailing light source of the scene. There also may be manual white balance controls that allow you to tweak the settings. A custom white balance is one for which you set the white balance to a specific lighting situation. You set the custom mode, lightly touch the shutter release button while pointing the camera at a white reference card, and the processor is then set up to balance the color in that lighting only.

White balance need not be used just for correcting color casts. You can use it as a way to add a touch of color richness or mood to a scene. You might set white balance to Cloudy for photographing fall foliage, to Flash for portraits even without flash, or to Incandescent for moody morning landscapes.

White balance is a way to render color so that it's not unduly influenced by the prevailing light. In some scenes, this will be an objective call; in others, it will be subjective. This photograph of the bridge in Heidelberg, Germany, was taken close to sunset and was made with a custom white balance setting to neutralize the color cast (opposite, top).

Compare this to the version made with the Overcast white balance setting, which enhanced the warm glow of the sunset (opposite, bottom). While the balanced rendition is probably more accurate in terms of neutral color, the "warmer" glow captures more of the mood of the moment.

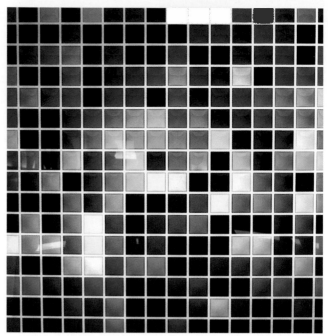

Some cameras have a white balance bracketing feature, which allows you to make one picture at the set (or Auto) white balance, plus one warmer and one cooler rendition. You can set the degree of bracket in Kelvin temperatures or simply as warmer or cooler for whatever setting you've made. These three color grids show a white balance bracket of about 500 degrees K, with the top left image on Auto, the top right image on a cooler white balance setting, and the image at left on a warmer setting.

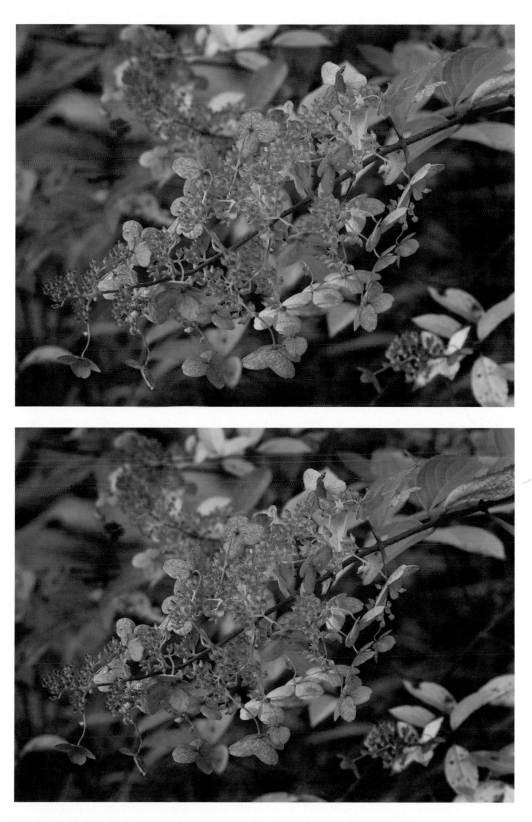

White balance isn't only a corrective measure; you can also use it as a creative tool that is like placing a color filter over the lens. I made this set of floral images with Cloudy (top) and Tungsten (bottom) white balance settings.

When you know that the color cast is undesirable and will get in the way of the appreciation of a subject or scene, use white balance to get "adapted eye" color rendition. I photographed this Mardi Gras prop inside under incandescent lightbulbs, which gave it the typical amber/red color cast (left). Switching to Tungsten color balance eliminated the cast and any need to work on it further in software (opposite). Note that in raw file format, you can change white balance in postprocessing with ease, whereas with JPEG or TIFF, it requires a bit more work.

How It Works

White balance is based on the Kelvin temperature scale, a visual scale that in essence goes from daylight at the "center" to red/amber/yellow on the visually "warm" side to blue on the visually "cool" side of the spectrum. Kelvin temperature is arrived at in a carefully controlled experiment by correlating the temperature at which an object is heated to the color light it emits. In photography, it has been used to codify the color of prevailing light and the ways in which that light is brought into "balance" (that is, to yield "true" color in whatever the prevailing light might be). Digital white balance replaces the color filters that were placed over the lens in film photography with color image processing that adds a color "wash" to the image.

Daylight in the Kelvin scale is about 5500 degrees Kelvin (K). Since blue heat is always hotter in degrees Kelvin than yellow heat, the Kelvin scale might seem counterintuitive. So, a scene dominated by a blue cast (such as high altitude landscapes and cloudy days) are *higher* on the scale, at about 6800 K to 7200 K, and those that are dominated by a yellow cast (such as interior photographs lit by household bulbs) are at about 2800 K to 3200 K. The white balance modes actually add color casts that counteract those readings, so an Incandescent setting adds a blue cast while a Cloudy setting adds a yellow one.

Make a series of pictures without flash outdoors in direct light, in shady conditions, and indoors. On each set, use three white balance settings on your camera—Auto, Shade, and Tungsten (or Incandescent)—so that for each shot you're taking three versions (one for each WB, or white balance, setting). Compare the results, and note how each setting alters the image.

Advanced Option

Work with the custom white balance setting to get exactly the color balance you want from the camera *in camera*, not later in software. Set up a white card in the scene that is struck by the prevailing light source, and use the custom white balance function on your camera. Make pictures with the custom white balance setting, then revert to the Auto white balance setting, and compare the results. Try this under various lighting conditions.

Aperture and Depth of Field

Focus is the way you make subjects sharp in a picture. When a lens is set at a certain focusing distance, only that distance is in focus; the other areas in front of and behind that distance might *seem* in focus, because we tolerate a certain "unsharpness" in our sight, but they are not. That tolerance in photography is the *depth of field*, a term that describes the range in space from near to far that seems sharp in the picture. That range may be shallow—such as in close-up photography—and as slim as 1 to 1½ inches; or, it might be broad—such as when a wide-angle lens is used at a small aperture—and from 1 foot to infinity.

There are three main factors that determine what depth of field might be. All three factors are interdependent, and changing any one of the them will affect the depth of field:

1. **Camera-to-subject distance**
2. **Focal length**
3. **Aperture**

The aperture setting is the diameter of the opening in the lens. Aperture numbers can range from, for example, *f*/2 to *f*/22. The higher numbers represent smaller openings. Each step in aperture number is referred to as a stop, and you can find the next whole stop by multiplying the lower number by 1.4.

With very wide-angle lenses, foreshortening—the exaggeration of closeness in the context of the whole picture space—can create many visual surprises. Here, I set focus on the blue painted rib on the stern of this boat and used an aperture of *f*/22 to create a depth of field from 1 foot to infinity.

Controlling depth of field is a key creative tool in photography. It allows for isolating a subject in an out-of-focus background, or for creating contextual sharpness throughout the picture space to marry subject with surroundings in a way that cannot be done with the unaided eye.

The automatic exposure mode for controlling depth of field is called Aperture Priority mode, for which you set the aperture and the camera's exposure system sets the shutter speed for what it considers to be the best exposure. When using this mode, the point of initial focus is key. Generally, that point is on the main subject, with all other considerations of sharpness or "unsharpness" emanating from that source.

Try It

Place your main subject 6 feet from the camera with a background that's at least 20 feet away from the subject. Then take two pictures: one with focus on the main subject and Aperture Priority mode set at the largest lens opening (*f*/2 or *f*/2.8, for example) and another focused on the same spot but with a smaller lens opening (*f*/11 or *f*/16, for example). Compare the results.

In addition, make a close-up photograph with a wide-angle lens set at *f*/16 (or the smallest opening) and also at the largest lens opening.

The eye sees sharpness in space by moving about rapidly and focusing on different points. The camera can only capture one "moment" of focus; the rest is created through depth-of-field effects. The highway lines here act as leading lines that stretch into infinity with initial sharpness beginning at the base of the picture's frame.

Wide-angle lenses and creative use of depth of field can also play with the scale of objects within a frame. This fire hydrant was perhaps 2 or 3 feet tall, while the street sculptures behind it were at least 8 feet tall. Keeping everything in focus with deep depth of field by using a small aperture lets the viewer visually compare them rather than see them as separate subjects.

How It Works

A lens gathers light and sends it toward the sensor. Light from different distances converges at different points, some right on the surface of the sensor ("in focus") and some before or beyond the surface ("out of focus"). The tolerance for what is sharp and not sharp is determined by a "circle of confusion," a cone of light created by divergence of the light rays from different distances before or after the sensor surface; a diameter smaller than this circle of confusion is often perceived as sharp, and one larger as not sharp. Narrower lens openings constrict the angle at which light enters and tend to gather the points of convergence and divergence closer to the surface than wider lens openings. This creates the sense that light from different distances is in focus, or creates a greater depth of field.

Cameras "show" you a scene through the viewfinder at the largest aperture available, as this lets the most light through for composing and viewing your potential picture. But this does not give you a sense of what the actual image will look like if you're photographing with a smaller aperture, which you generally will do. Many DSLR cameras have depth-of-field preview, a mechanism that allows for viewing of the scene at the set aperture. This gives you the advantage of seeing what will be sharp and not sharp before you make the picture. It's a very important creative tool, so much so that if a DSLR camera doesn't have this feature, you shouldn't considered purchasing it.

Advanced Option

One of the factors in depth-of-field calculations is the focal length of the lens. You'll get quite different results if you photograph with a wide-angle lens than you will when you use the telephoto focal length ranges. To create the shallowest depth of field, photograph with a telephoto lens from fairly close up at a wide-open aperture. Photograph the same subject with a wide-angle focal length setting from the same apparent distance (that which emulates the framing of the telephoto) with a very narrow aperture setting.

Depth of field can be used to isolate subjects against a distracting or irrelevant background. These tiny milkweed seeds and wisps are small and incidental as you walk by them in the fields. But getting close up and using a fairly wide aperture softens the background and makes the subject stand out on its own.

Shutter Speed

Think of shutter speed as a slice in the arc of time, with faster shutter speeds making a thinner slice than slower ones. Shutter speeds of 1/125 sec. are common in photography, while those of 1 second or longer are rarely used and are actually quite long in photographic terms. The most important shutter speeds are those that allow you to get a steady picture, usually 1/60 sec. or faster. At speeds of 1/30 sec. and below, you'll need to steady the camera on a tripod, or in some other fashion, to avoid "camera shake." A blurry picture that's the result of *camera motion* rather than of *poor focusing technique* shows the effects of camera shake. Image stabilization systems and specially built lenses might allow you to shoot at slower speeds handheld.

When you photograph in fully automatic or Program mode, the exposure system will always favor a faster shutter speed as its first default. When you photograph in Shutter Priority mode, you set the shutter speed you feel will fit the image (or get you a steady shot), and the exposure system picks the aperture for what it considers a correct exposure. If there is not enough, or too much, light, an under or overexposure warning will usually appear in the viewfinder, and you'll have to make your shutter speed either faster or slower to get a good exposure. This generally occurs in low-light scenes in which you don't have enough light even at maximum aperture to get as fast a shutter speed as you want. You can always raise the ISO to regain your desired shutter speed.

Shutter speed settings can also affect results when using flash. If you turn your flash on in Program or autoexposure mode, the system sets what's known as the *flash sync speed*, usually 1/125 sec. or 1/250 sec., the fastest shutter speed you can use with flash. This is okay for some flash shots, but you'll get better flash/ambient light results if you set a slower shutter speed. This helps avoid the "tunnel effect" you get with on-camera flash, when the foreground subject is well exposed by the flash but the background becomes dark. Setting a slower-than-sync-speed shutter speed allows more ambient light into the scene and gives a more natural effect.

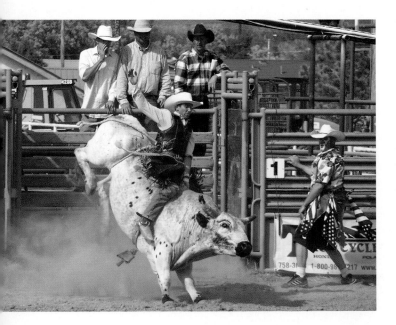

The most common use of Shutter Priority or shutter speed control is to stop action. High shutter speeds can freeze moments that the unaided eye will never catch. I made this rodeo photo with the camera set to Shutter Priority mode at 1/1000 sec.

Try It

To see the effect of various shutter speeds on action subjects, set up your camera to photograph at disparate shutter speeds, such as 1/2000 sec. and 1/4 sec. Be sure to brace or steady the camera at the slower shutter speeds. Try this with a sports game and with running water. Note when you "run out" of aperture settings as you go to the faster and slower settings, and change ISO when needed.

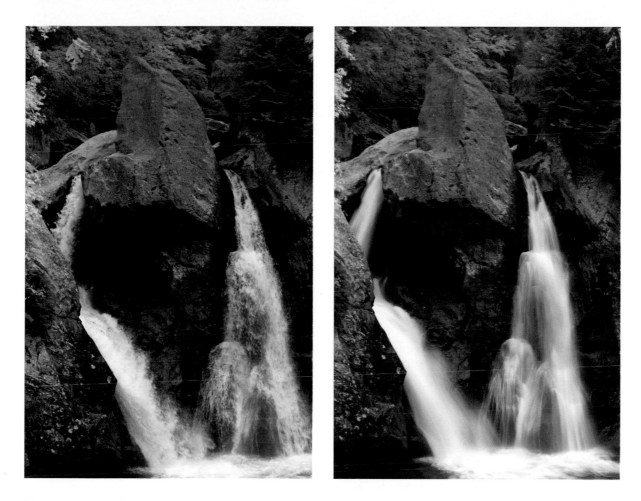

There are times when you can use a slower shutter speed not only to aid in gathering more light in dim lighting conditions but also to depict motion in different ways. The classic example is a slow shutter speed treatment of flowing water. Here, I changed the exposure from 1/125 sec. (left) to 1/15 sec. (right), a 3-stop change. The aperture changed from f/5.6 to f/16. These settings are what is known as equivalent exposures, or different combinations of aperture and shutter speeds that result in the same amount of exposure but yield different image effects.

How It Works

Many digital SLR cameras still utilize the shutter gate used in film reflex cameras, which means that light is allowed in through the action of a shutter mechanism located behind the lens and in front of the sensor. The gate has leading and following curtains that create a slit, or opening, timed to set shutter speed. Shutter speeds as fast as 1/8000 sec. are possible with many digital SLR cameras.

Cameras have a shutter speed range in automatic modes (any modes in which the exposure system chooses aperture and shutter speed for you). This range can be anywhere from 30 seconds to 1/8000 sec. in some cameras. Longer shutter speeds may be possible with a B, or Bulb, setting, which keeps the shutter open for as long as pressure is maintained on the shutter release button.

I made this photograph with the flash on in Program mode, with no changes in shutter speed settings (left). The flash exposure did okay with the floral arrangement, even if it is a bit harsh. But because the exposure was "quenched" by the exposure system after it read proper exposure on the foreground subject, no light from the surrounding area is recorded. This is a classic tunnel effect.

A much more natural effect is gained with a slower shutter speed when using flash (opposite). The flash still illuminates the foreground subject (which otherwise would have fallen into deep shadow), while the longer shutter speed allows in more ambient light. The shutter speed was 1/30 sec. here.

Advanced Option

While fast shutter speeds are fascinating in what they can reveal about subjects in motion, the slower shutter speeds are perhaps even more intriguing because we have become so used to action-stopping shots. Set your camera at 1/8 sec., use a tripod or other steadying setup, and photograph subjects in motion. Do so at night, when lights from cars might be trailing away from you, or during the day to reveal a different kind of time/space continuum. Set your camera to the lowest ISO to aid you in attaining slower shutter speeds in brighter light, or shoot on an overcast day or in the shade to avoid overexposure.

Metering

While you can always check exposure as you make an image by looking for an overexposure warning display (see page 55) or using the histogram, proper use of metering patterns and exposure lock can ensure that you don't lose fleeting shots or have to repeat pictures to get the exposure right. In addition, since highlight control is so important in digital photography, you should become familiar with the way your camera reads light and how to retain details in all areas of brightly lit and high-contrast scenes. (See page 90 for more on exposure compensation for highlights and high-contrast scenes.)

The camera uses what are called metering *patterns* to read the light in any given scene. One of those patterns is called *center-weighted averaging* metering (CWA, or usually just CW), and another is called *spot* metering.

Center-Weighted Metering

The center-weighted (or center-weighted-averaging) metering pattern reads the light from all parts of the scene but gives most of the weight of exposure calculation to what's in the center of the viewfinder (imagine a sort of small, egg-shape area within the rectangular eyepiece). CW (or CWA) is best used when there's a large, bright area in a scene that also has a mix of other values that might otherwise throw off the meter readings. This type of lighting situation generally occurs late or early in the day, when the sun is slanting across the horizon, but also happens when there are any large shadow areas in bright light.

The best technique is to place the center of the frame over the bright area, use AEL (autoexposure lock) to hold the reading, and then recompose and release the shutter. Don't let the bright area completely dominate the frame by zooming in on it, and avoid bright reflections from the bright area in the scene, as this will throw off readings and result in excessive underexposure.

At left is a classic CW pattern scene: Rays of light come from the side and illuminate a part of the scene while much else is in shadow. Here, I placed the viewfinder right over the bright face of the building, activated the exposure lock, recomposed, and exposed. This image required no exposure correction later and definitely avoided overexposure.

In the scene opposite, the sun sat behind the tree limbs, in the upper left of the frame, informing the tress in the fore-ground with bright backlighting. The simplest way to get correct exposure was to use a CW pattern, place the center of the viewfinder right over the bright leaves in the middle to lower right, lock exposure, recompose, and shoot. If I had taken an automatic, matrix, or evaluative reading, there's a good possibility that the brighter areas would have become too overexposed. Making the reading yourself gives you so much more control over light values.

This could have been a tough reading, given the bands of bright light and shadow in the foreground. Rather than struggle with potential problems, the easiest approach was to switch to a CW pattern, point the camera at the sky while still including some of the horizon at the base of the viewfinder, lock exposure, recompose, and shoot. That's how I made this exposure, right out of the camera.

How It Works

Center-weighted averaging (CWA) describes how the meter gathers the light from the finder and what it does with it to calculate exposure. This is the "relic" of in-camera light-reading setups, as it has been in use ever since through-the-lens (TTL) metering became available in the mid-twentieth century. *Center-weighted* refers to the fact that the light gathered is from all parts of the viewfinder but that the light in the center (in an oval shape that extends toward the edges of the frame) is given more weight in the metering system's exposure calculations, usually 70/30, center to edges.

Averaging refers to how a final exposure is reached. Assuming a fixed shutter speed, the meter takes the brightest reading (say, f/16) and the darkest reading (say, f/4) and, according to the intensity or proportion of those values in the scene, creates an average, like f/8. Since the exposure is made with a fixed aperture, and cannot adapt to varying light intensities like the eye can, it cannot deliver the correct exposure for all values. What it does, however, is sort those values, if you will, from highlight (bright) to shadow (dark). Since all these values work in lockstep, the average of the bright and the dark retains the bright areas as bright in the recording. If, however, exposure is made for the brightest part of the scene only, then the darker parts of the scene would become very dark. Similarly, if you would expose only for the dark values (say, f/4), then the bright values (f/16) would be very overexposed and would render the image useless.

Try It

Find scenes that would benefit from the use of CWA metering mode, especially those with highly "directional" light enhanced by deep shadows. Make a reading that incorporates the brighter areas, and lock that reading and expose. Then, make a reading with the fully automatic (or matrix or evaluative) mode on the camera, and compare.

Advanced Option

The center-weighted metering pattern option is most useful in bright, even high-contrast light. Set the camera at that option, and on a bright, sunny day, take pictures using only CWA and exposure lock. Review the images as you work. Don't use exposure bracketing or compensation, and develop an eye and a quick technique for ensuring that highlight values aren't overexposed.

Spot Metering and Silhouettes

In lighting situations other than those just discussed, you may want to take a meter reading from only one specific area in a composition. At those times, use *spot metering*. So while, for example, there are many times when you want to get all the color and detail out of your subjects that you can, there are other times when you might want to create silhouettes, using the subject as a graphic form.

It's easy to create a silhouette in photography given the right lighting conditions. Position yourself so that the subject is between you and the main light source, and be sure it serves your compositional needs. Watch out for distracting forms that would obscure your goal. When you meter, simply switch to spot metering mode, and point the spot section directly at the background—but avoid pointing your camera, or looking, directly at the sun, of course. If you don't have spot metering mode, meter off the brightest area of the sky. Take and lock the reading, and your exposure will create a perfect silhouette, such as this lighthouse at Fort Point, San Francisco.

Try It

Find a subject that would make an interesting silhouette, such as a freestanding structure, tree, or sculpture, and move so that it sits between you and a bright light source. Take a reading from a bright area in the scene, lock the exposure, and shoot.

Advanced Option

Use spot metering as a way to work with exposure compensation (see page 90 for an explanation of exposure compensation). Meter a bright, white subject, and open the aperture up 1 to 2 stops. Meter a very dark area, and close the aperture down 1 to 2 stops. When you use the spot meter in this way, you're first reading specific values, and then "moving" those values around to change how they record. For example, if you "spot" on bright white snow, it would record as gray; adding 1 or 2 stops makes it brighter—and truer.

Spot Metering and Backlit Translucent Subjects

Spot metering is ideal for making good exposures of backlit subjects, but it can also be the best way to capture all the color and detail of backlit translucent subjects, such as stained glass windows or fall leaves. When making readings, no exposure compensation is required as long as you've placed the spot meter target on a color or tonal value other than bright white or reflective white.

The light here is coming from directly behind these stained glass windows in Cologne Cathedral. I placed the spot meter right on a saint's face and didn't need any exposure compensation.

How It Works

Translucent subjects transmit the light that shines through them from behind, yet still maintain much of their color and form. Spot metering is helpful in capturing this effect in that it focuses in on a single brightness value. When photographing a church window with strong backlight, this means that the clear panes of glass—and even the window frame—will not influence the meter reading. And any time you spot meter a brightness value, you "saturate" it to a middle gray contrast, and thus see the full richness of the color.

Try It

Seek out translucent subjects, such as leaves and flowers, in strong backlighting, and position yourself so that they are between you and the light source. Meter off the subject, not the backlight, using a spot metering pattern; practice selective metering to gain experience in capturing the most intense backlighting effect.

Advanced Option

Spot metering is also a great way to capture neon signs, billboards at night, and other bright subjects. Keep in mind that when you do this, most of the other values in the scene will go quite dark. Use spot metering to see just how you can control the way light and color records in various situations.

Exposure Compensation

Although many photographers enjoy the challenge of wrestling with light to get a good exposure, the automatic exposure system in modern cameras (film, as well as digital) does a very good job with the majority of lighting situations and conditions. Digital cameras are even better in this regard because they remove a number of exposure problems that could plague film photographers. Raising and lowering ISO to enhance or increase light sensitivity certainly helps, as does the fact that moderate underexposure is less of a problem.

However, there's one exposure situation that requires your attention in digital photography, and that is the way in which highlights are exposed. Highlights are simply the brighter or brightest light values within the frame. In most lighting situations, the sensor range of recording handles these bright areas with no problem. However, if there's a high-contrast condition (one with both deep shadows and very bright areas) or the image is composed primarily of bright whites (such as a sunlit snow scene), then you should make some *exposure compensation* (using either the exposure compensation or exposure lock features on the camera) to properly record those values. And, you can make that compensation, or camera override, in a number of ways, each dependent on the situation.

This scene is dominated by bright white, and the only contrast is in shadow areas. However, if you make an exposure as framed here, the metering system will average the light values it "sees" and turn them middle gray. This setup works fine for scenes with a range of values, as averaging or even matrixlike metering will do the trick, but it doesn't work when there's bright light or white dominance. At left is how the scene records without any overrides—the white turns an unacceptable gray.

While you can easily fix this in software, to do it in camera, set the exposure compensation to +1. This brings the exposure system in line with the light values of the original scene (right).

A high-contrast scene becomes more problematic when the bright and dark values are in a much broader range. For those photographers who've worked with film, the exposure technique is very similar to how you handle slide film: You expose so that you bias for the highlight values. Contrasty scenes will require some intercession on your part (you simply can't point and shoot as you might with most scenes), or you'll have a problem exposure on your hands. So you'll need to be aware of the highlights and to bias for them accordingly, meaning give them more weight in your exposure. You can still use automatic exposure, but biasing means using either exposure lock or exposure compensation techniques, or a combination of the two.

This scene presents a particular challenge. The whites are very bright, but there are also other values of interest in the scene. Nevertheless, the bright whites must be taken into consideration, otherwise they might become overexposed. This requires making a "highlight" reading *and* using exposure compensation, not just using exposure compensation alone, as in the previous example.

You can take the highlight reading with a spot meter or a center-weighted meter pattern. Place the metering pattern over the white area with the camera set for highlight compensation (in this scene +1.5 EV), lock exposure using the autoexposure lock (AEL), and then recompose and shoot. This will ensure that the bright whites stay bright, with texture and detail.

When the highlight (the brighter part of the scene) isn't bright white, you should be able to place the metering pattern over the bright subject, lock exposure, recompose, and get a very good exposure. This exposure was right in the camera without software manipulation later. The shadow areas could be made brighter in software, but the highlight values are perfectly exposed. I used a center-weighted metering pattern, taking the reading by pointing the camera at the bright green lawn in the foreground and including some of the surrounding areas. I then locked this exposure before recomposing the scene.

This scene has a complex range of values. The trick in scenes like this is to identify the brighter values and make selective exposure readings. I made the reading here right from the green palm frond in the lower center part of the frame.

There are times when exposing or biasing for the highlight value can make the shadow values in the image seem dark. They may well be, on initial review, but digital gives you leeway in the shadow areas. This is a straight exposure from the camera with the meter reading made exclusively from the sky (left). The sky looks great, but the ground is a bit too dark.

It's a simple matter to open up the darker shadow areas later—much simpler than it is to try to reclaim the brighter areas should you expose solely for the ground in this scene. If you expose for the ground (center), the sky gets quite "burnt up"—and this will be very difficult to reclaim later.

But, here's the "darker" first version after some easy work in software (right). The work reclaims the darker areas while retaining richness in the sky.

How It Works

Think of the photo sites (pixels) on the sensor as a well that fills with light. Darker areas only partially fill the well, while brighter areas fill it toward the top. When a photo site is grossly overexposed, the light spills over the edge and is drained away—and no more information records. To an extent, the darker areas can be "opened up" later in software, but if there's no information beyond totally bright white, then there's little you can do to salvage any texture or tone from overexposed areas.

The trick is to expose so that you will have some information recorded in all areas and to not allow large areas of bright white or highly reflective colors to record without some texture or tone. You do this by biasing exposure toward those highlight areas. If there are flecks of bright overexposure—such as the reflections off water droplets, a lake, or a stream known as *specular highlights*—there's no cause for concern. But large areas of overexposure—such as a bright sky or wall—degrade image quality and make it look too contrasty and harsh.

Try It

Make a series of landscape photographs in which there's a bright blue sky and clouds. In each case, use center-weighted metering, and lock your readings when you make the picture; make one exposure reading solely from the ground, one reading solely from the sky, and one from an average of the two (or reading from the horizon with equal weight in the sky and in the ground area). Compare the exposures, and note when the sky records best.

Advanced Option

Set your camera at +1 or +1.5 exposure compensation. Choose the spot metering exposure pattern. Work on a bright, sunny day. Find scenes with bright highlights, and expose by locking exposure on those areas.

Bracketing

If you're in doubt about how to make an exposure reading of a scene, or the light is challenging your sense of how to best get all the information in your exposure, try bracketing. This is when you take a series of exposures (usually three, five, or seven) that brings in more and less light than the meter indicates for one exposure. Many cameras have an autobracketing mode, which will make the exposure adjustments for you in various set sequences, such as "normal" and plus and minus the normal exposure. If you use this in conjunction with continuous shooting mode, you can get off three or even five shots in the bracketing sequence fairly quickly if need be.

You can bracket in any exposure mode and metering pattern. If you work in Program automatic exposure mode, the exposure system will pick either the aperture or shutter speed values when bracketing. If you want to bracket in shutter speed values, select bracketing and work in Aperture Priority mode; if you want to change aperture in the bracketing steps, work in Shutter Priority mode.

Bracketing can also be set up in various increments of change, from 1/3 EV in some cameras to 1 or even 2 EV increments in more advanced cameras. In general, a 1 EV change (either a change in 1 stop of aperture or 1 step in shutter speed values) is a good place to start, as this will show some change; smaller increments are for more subtle changes.

This photograph of a palm tree swaying in the wind in sunset light was difficult to read, because the subject kept moving through the frame. The meter would read shadow areas one second and highlights the next. To minimize any problems during exposure, I chose a bracketing sequence with a center-weighted metering pattern. To keep the shutter speed constant so that there would be no blur from the motion, I also selected Shutter Priority exposure mode.

Each exposure has its attributes. The -1 EV bracket (center) creates a richly colored image with very deeply textured highlights. The "normal" exposure (top) bridges the gap between highlights and shadows nicely. The +1 EV exposure (bottom) opens up the shadow areas. While all are acceptable exposures that could be worked on with ease in software for further enhancement, making three bracketed shots ensures that you'll get exactly what you want from the light values in a scene.

The "normal" exposure read by the camera: f/8 for 1/250 sec.

The -1 EV bracket: f/11 for 1/250 sec.

The +1 EV bracket: f/5.6 for 1/250 sec.

How It Works

Bracketing is a way of placing your exposure bets across the field of play, hoping that one will come up a winner. It adds to and subtracts from the light meter reading that would ordinarily be used for a shot to encompass light values that might otherwise be difficult to ascertain. To bracket, you first make a reading as you would ordinarily, and then determine how great a deviation from that reading would encompass the light values in the scene. In other words, in a very contrasty scene, you would bracket in greater EV increments than you would in a situation in which you are bracketing for nuance of color or tone.

When you set up the bracketing sequence, make sure you actually shoot the number of exposures you've selected for that sequence, otherwise the system will apply that bracketing setting to your next subject (for which you did not intend the bracketing).

Try It

Pick out two scenes, one with fairly high contrast in which the main subject falls in bright light, and one with similar contrast but in which the main subject falls in shadow. Make a reading as best you can, and then set up a +/- 1.5 EV three-shot bracketing sequence. Place your camera on continuous advance/low so that there's little variation in your framing. (Note: You can also bracket in manual exposure mode, but make sure the camera is mounted on a tripod so that you don't lose the original framing when you make changes to exposure settings.) Compare the exposures, and use the lesson learned to make future readings that eliminate the need for bracketing.

Advanced Option

The usual bracketing sequence is the "normal" exposure, then the plus/minus exposures follow. You can also bracket from any exposure compensation setting; that is, you can make the "normal" or middle of the bracket set the minus or plus exposure compensation reading. For example, say you know you want to make values darker overall but are unsure of the exact exposure compensation to use. Set the exposure compensation to -1.5 EV to start and then set the bracketing increments to 1 EV. The three exposures will be -1.5 EV (for normal), -0.5 EV (for +1), and -2.5 EV (for -1 EV).

Sunset exposure readings are sometimes tough to call, but having a variety of exposures gives you more options later. So, a sunset is a perfect example of a subject for which exposure bracketing can come in handy. I generally underexpose whatever reading the camera makes in order to get richer color and more gradation in the sky. This shot is from a bracketing set that began with -1.5 EV exposure compensation, so the three shots in the set were -1.5 EV (normal), -0.5 EV, and -2.5 EV. The mix of darker foreground, deep shadows on the boats, and brighter horizon line made this a tough exposure to call, as it turned out.

Fill Flash

Many digital SLRs have a small, top-mounted flash that can be used as a *fill flash* (a small burst of light that brings a touch of light to deep shadows in the foreground of your pictures). The flash may pop up automatically if the camera meter senses that there isn't enough light in the scene for correct exposure, or you can manually raise the flash via a button usually located to the left or right of the flash itself.

Fill flash isn't meant as a long-range solution to low light—it is generally good to about 8 feet, although you can extend the coverage somewhat by raising the ISO setting. It is also what is known as a "point" light source, meaning it's not the most complimentary light since it is direct and harsh; so, use it only when absolutely necessary. However, there are times when it can be quite useful for adding visual detail to dark subjects in the foreground of your pictures.

This is a good example of when fill flash can come in handy. The statue is quite dark without fill flash, but with it, the detail becomes more apparent. In this situation, there was enough natural light in the scene that the flash did not come up automatically; I had to raise it manually.

Fill flash need not just be used to add light to foreground shadows. It can also be used for many creative techniques. I made this photo via double exposure, taking the first of the two images without flash. For the second image, I first changed the focusing point on the lens slightly (with the camera mounted on a tripod) and then exposed with the flash on. The flash exposure became the dominant (brighter) exposure, while the nonflash exposure provided the deep shadows and slight ghosting effect.

There are times when using fill is a judgment call. True, there may be a dark subject in the fore-
ground, but it could be treated as a compositional element rather than as an object that requires
better illumination. That's what I did here. First, I made the light reading from the brighter areas of
the pond surface using center-weighted metering, aimed the camera at the brighter area to the
right (where the leaves floated on the pond surface), and locked the exposure. I set saturation at +1
to enhance the colors (see page 94). I made one version without fill flash, the other with it. In this
case, I prefer the nonflash interpretation.

How It Works

The power output or coverage of a flash is determined by its guide number (GN), with higher GNs yielding coverage over greater distances. To find the distance a flash will cover, you divide the GN by the *f*-number used. For example, a fill flash on a camera might have a GN of 48. If you use *f*/8 for the exposure, the coverage will be about 6 feet (usually a bit more, depending on the reflectivity of the subject). Shoe mount, or auxiliary, flash might have a GN of 160, more or less, which means that at the same ISO, you get 20 feet of coverage at *f*/8. You can extend the flash coverage range by raising the ISO setting. Fill flash is not intended for general work, such as photographing at weddings or events, but is more appropriate for adding just a touch of light to foreground subjects.

Try It

Find a scene in which the foreground subject sits in shadow with a brighter background. Set your camera on P for Program mode. Make one photograph with the flash on and one with it off, and compare the detail in the foreground subject. Keep the foreground subject no more than 8 feet from the camera.

Advanced Option

Fill flash comes in quite handy for close-up photography, but when using fill close, you might have to work with the camera's flash exposure compensation feature to prevent the subject from becoming too harshly lit. This control allows you to dampen the flash output, in some cases up to -3 EV. Find the flash exposure compensation control on your camera, and once you have the flash raised, press it—then spin the control or command dial to attain a minus setting.

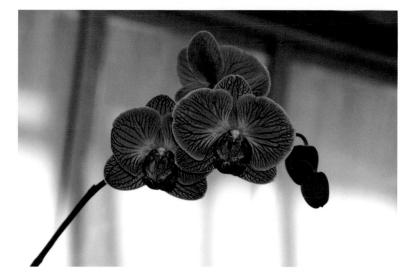

I made this photo at -2 EV flash exposure compensation. If I hadn't used flash, the flower would have been totally in shadow. But, lowering the flash output ensured that it wasn't overexposed, as often happens when making close-ups with a built-in flash.

Color Saturation

Color saturation refers to the vividness of color. In a scene, it is determined both by the brightness of the color or colors in the subject and the brightness of the light source illuminating the subject. Changing saturation doesn't change the hue (the color itself) but affects the richness of that hue.

At first, it might seem that adding saturation is the best course, as it often lends a very attractive look to many subjects. But staying with "natural" color (the default setting in the camera), or even diminishing saturation, can be equally effective. Portraits rarely benefit from increased saturation, while floral subjects often do. If an image is completely "desaturated," it will be monochrome, or black and white. The black-and-white setting in your camera is just that—a desaturation command—even though the image retains its RGB (three-channel) status.

How It Works

You have control over the degree of saturation via the Saturation settings in your camera Recording menu. The range of saturation options generally extends two increments, in both the plus and minus directions. The plus setting increases saturation, with +2 being quite dramatic; the minus settings decrease saturation, with more than -2 being close to a monochrome rendition of the subject. The Saturation setting in the camera affects all colors equally; it's a global adjustment across the entire range. Keep in mind that nearly every brand of camera will interpret these settings differently and that you have more control over changing saturation in processing software.

Camera default color saturation

+1 color saturation

The factory setting for saturation is the camera maker's *opinion* on proper color saturation for subjects and scenes. It is opinion based on research and color science, but it still might not be what you consider the best saturation choice for your photographs. Compare the difference between the camera's default color rendition and other saturation settings. Again, keep in mind that when you adjust the saturation setting, you are doing so globally, affecting each color and tone equally throughout the image.

-1 color saturation

Camera default color saturation

+1 color saturation

Try It

Pick three subjects—a portrait; a wall mural or bright, colorful object; and a floral or landscape—and make three photographs of each, one with the camera default for saturation, and one each with plus and minus saturation settings. Open them later side by side on your computer screen, and note the differences, keeping them in mind for similar scenes later.

Advanced Option

Choose one saturation setting (other than 0 or the manufacturer default), and use it for a full day's shooting, choosing subjects and lighting that are in harmony with your color saturation choice. Try this with other settings, as well, to train your eye to get the most potential from the various camera settings.

Contrast

Contrast settings have two functions in the camera. One is to enhance contrast to make a more graphic rendition of a scene. The other is to control high contrast as best as possible when making the picture. Both can be creative choices, although the latter is often an attempt to correct for difficult lighting. As you work with different subjects and scenes, you'll get an instinct for when to use these settings both creatively and correctively.

You can make these adjustments after exposure in software, as well; in fact, with contrast enhancement, you'll have much finer control in software later and be able to set just the degree of contrast you want. When shooting in high-contrast situations, making a lower contrast setting can help, although you'll only be able to reduce the contrast as much as the camera menu settings allow. There are many software controls for going beyond those settings, but exposing a lower contrast version in camera can sometimes be helpful.

When you encounter a high-contrast scene, you have a choice of enhancing the contrast or suppressing it. Here is a reflection of the Empire State Building. After I made this exposure, the overexposure warning came on (above). The brighter areas read as overexposed. For my next attempt, I accessed the camera's Contrast setting menu and chose a -1 setting (right). Note how the brighter areas are more under control.

You can modify contrast later in software. But this exposure is much better, regardless of how the final contrast adjustments are made, as there's detail in the brighter areas and the overexposed area has been taken care of.

Some scenes benefit from increased contrast. You can always do this in software after exposure, but you might want to experiment with the plus-contrast settings in your camera, as well. The lack of color in this black-and-white pair of images keeps the focus on the contrast change, but note that increasing contrast in camera for scenes with more color will also increase the color contrast, which influences color saturation.

The straight exposure is on the left. Opening the Contrast menu and changing the contrast setting to +2 (right) emphasized the lines and forms.

How It Works

The image processor in the camera has various presets for contrast, saturation, sharpness, and so on. When you make a menu choice to change contrast, you are engaging one of those preset "curves" and applying it to the image. The in-camera contrast changes are usually limited to four or five options; you have many more options in software after exposure.

Try It

Pick scenes that are not dominated by a strong color. Photograph a high-contrast scene at the default setting and at a -1 or -2 contrast setting. Then photograph a flat-lit scene also at the default and at +1 or +2. (You can determine if a scene is flat lit, without much contrast, by making exposure readings throughout areas of the scene and seeing that the exposure does not change much as you move the camera.)

Advanced Option

Set your camera at a +2 or -2 contrast setting and use it for the day. Review the first few images, then photograph without checking the review, and see if and how the setting you made alters your perception and the type of images you make.

Sharpening

Sharpening has to do with the perception of sharpness but has nothing to do with focusing. It is a digital manipulation that actually increases the edge contrast of the pixel, and higher contrast tends to make photos look sharper. Most digital cameras apply some sharpening in normal image processing. Some professional-level cameras don't apply sharpening, as manufacturers assume that the photographer will choose to apply the preferred degree of sharpening after exposure. This might make some images look "soft" or lacking in snap or even slightly out of focus. If images do look soft, and you have set focus correctly, it might be that the sharpening option in the menu has been turned off or is at a low setting. It's possible to increase sharpening later in software, though decreasing a sharpening setting is more problematic.

If you apply sharpening over and above the camera default setting, it's best to do it in postprocessing, when you can more carefully control the degree of sharpening. However, there are times when you can set sharpening in the camera—after testing to see each setting's effect—to make less work later. For example, if you're making copies of documents, or seeking a graphic or higher-contrast interpretation of an image, you can set higher sharpness. For portraits, lower sharpness can make for a more flattering image.

Graphics or copies of printed documents can benefit from in-camera sharpening. For my first attempt (above left), I photographed this signpost using the camera's default sharpen setting. (Again, most digital cameras apply some sharpening at default.) At +1 sharpness (above right), the image has added "snap," and the clarity of the lines is enhanced. From testing, it's clear that this camera system requires the user to add sharpness in camera, or later in software, for best results with this type of image. But note that oversharpening alters the image considerably, and while this can be an interesting effect, it can be too harsh for most subjects and scenes. The in-camera sharpening setting at left was +2.

You can also decrease the sharpening setting for portrait and floral subjects, which can benefit from a little softening. Keep in mind that sharpening and focusing are distinct functions, and that you can have subjects in focus and rendered softer, as if you have put a portrait or soft-focus filter over the lens. You can also do softening in software later using Blur layers and effects.

There's no problem with the portrait at left in terms of sharpness or focus, but setting lower sharpness—without changing contrast or color settings—can make for a nice effect, as well. The bottom image was made with a -1 sharpen setting. The difference is subtle but will be noticeable when larger prints are made.

Some digital cameras have a Portrait "image optimization" mode, which will automatically lower sharpness settings for you. In some cameras, Portrait mode both sets a wide aperture to create a soft-focus background for the portrait subject and decreases the sharpness settings.
PHOTO: GRACE SCHAUB

How It Works

Although they might seem similar and are often used together, Contrast and Sharpen controls differ. Contrast changes what is known as the "tone curve" of the image and affects every value throughout the image, including color and especially very light and very dark tones. Sharpen affects only the edges of the pixels by raising the contrast at or softening (blurring) those edges, depending on the setting you make. You would raise contrast to bring more snap to an image of a dull overcast day, though you might not sharpen it. You would sharpen an image to add more definition to subjects that have distinct tonal edges, such as signs, graphics, and type. You might lower contrast in a high-contrast lighting situation, but not necessarily for a portrait in which the light is fine as is; however, you might use a lower sharpen setting to get a more flattering photo of your portrait subject.

Try It

Make a photograph of a page of text at the camera's sharpen default, at +1, and +2. Note the difference in the readability of the type. Make a portrait using the default, and -1 and -2 sharpen settings. Note the rendition of the skin tone, and how sharpening changes the effect of lighting.

Advanced Option

Change the sharpen setting to +2, and keep it in a setting bank or memory bank and take the camera out for an afternoon's shooting. Keep an eye out for subjects that might benefit from more sharply defined lines and edges. Review the images, and then try out the -1 setting and make the same journey.

Color Matching vs. Color Mood

When we think of a color, we make associations that describe what that color looks like. The hue red, for example, can be the soft red of a rose, the deep red of an apple, or the metallic red of a fire truck. These subjective descriptions count on our visual experience to make a picture of the red in our mind, but they are all modifiers of red.

The image processor in a digital camera acts like a modifier, as well, making decisions about the red recorded in the original scene. The aim of most digital camera manufacturers is to keep any color subjectivity within reasonable limits and to ensure that the red that's recorded is close to the red that you see.

There are times when you want image color to exactly match subject color. This can be quite important to professional photographers who are paid to deliver a specific red on a sweater for a catalog or an accurate skin tone on a portrait. But color need not always be that exact; there are times when color mood is more important than color matching. With digital, you can match colors through the use of various controls, such as white balance (which deals with the influence of the ambient or prevailing light in the scene), color tone settings (for adjustment of color bias), and exposure (how bright or dark colors record). You can also use those controls to enhance color mood, with less care about color matching and more emphasis on the emotional power of color in the scene.

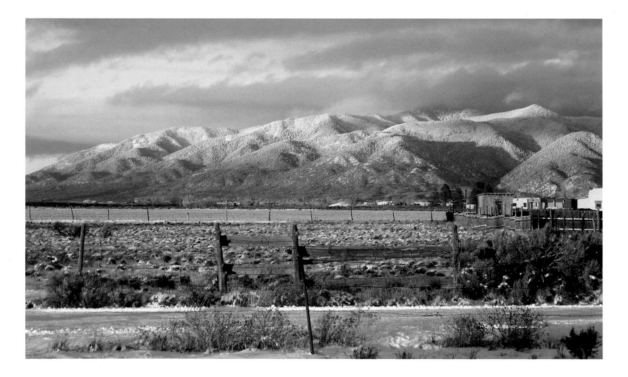

The "corrected" version (above) used white balance, color bias, and exposure settings "by the book" to achieve "proper" color. The original version (opposite) was made with auto settings on white balance, color bias, and exposure settings. While it might be too warm (having a yellowish bias), it is quite close to the sunset light at the time of exposure and is certainly a more emotional rendition.

At left is the original scene as recorded by the camera by Program exposure mode and auto white balance, bias, and exposure. The version opposite was made with an intentional blue color bias (from a photo filter in the Recording menu in the camera) and -1 stop exposure. It's not how the scene looked but more the way it felt, and thus makes the picture serve as an expression rather than a document.

How It Works

The image processor inside your camera is programmed to deliver as true a color as possible and to closely match the results with what the eye sees. A specific color in digital photography is created through a specific code. That code, however, can be altered in many ways that affect how color is recorded. When you alter color bias using your camera menu, for example, you are, in essence, reprogramming how a certain color should deviate from how it was recorded. Fortunately, no code writing is required; just practice with the controls to see how they alter color and, more important, how you choose to use color in your work.

Try It

Make a photograph using all the auto settings (which are the default, or factory, settings of the camera), and make the same photograph altering color bias or white balance settings. Then, make one photograph using settings that match the colors in the scene as closely as possible, and photograph the same scene using an expressionistic, emotional color interpretation.

Advanced Option

Set your camera controls with a combination that delivers a decidedly individual color bias or interpretation. Try high saturation with a warm bias via white balance controls, low contrast with a cool bias, and so on. Keep the settings on your camera for a full day of shooting, and note how they influence what you see and choose to photograph.

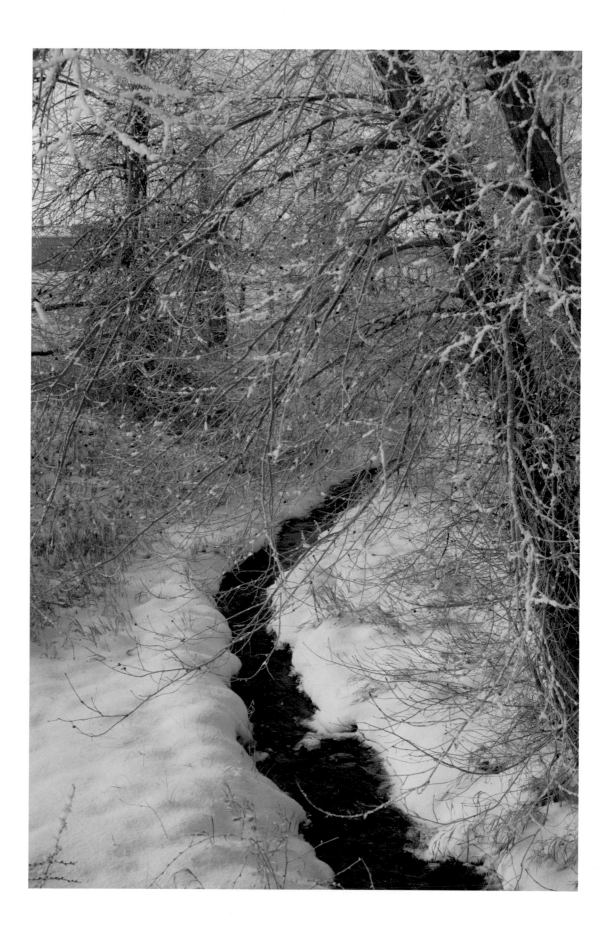

Color Bias

A number of digital cameras have a color processing control known as Color Bias or Color Tone, and sometimes as Color Shift. Using this control is very much like placing color filters or gels over the lens. It differs from white balance in that it doesn't adjust for the light source but instead creates a color cast on the image as a whole. This effect is quite simple to apply in software later.

Some cameras offer controls that allow you to set the degree of effect, or display an "axis" of color with shifts being in a blue or yellow direction and a violet or green direction. You can move through these changes by choosing Color Tone in the menu. While all this might come in handy if you want results right out of the camera, the degree of control is much greater in software later.

These snapdragon images provide a comparison of various color casts.

Default camera settings

Amber cast (yellow/red shift)

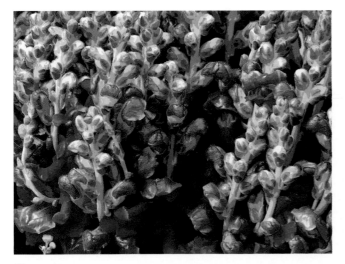

Blue cast

Green cast

Magenta cast

How It Works

When a color shift or bias is selected, the image processor overrides the default settings and tints the image with the chosen color. This is similar to adding a very transparent color wash that alters, and mixes with, the underlying or initially recorded color. When the tint and the underlying color are similar, the initially recorded color will be enriched; when a contrasting color is used as a tint, the initial color will be diminished.

Try It

First, identify which color shifts your in-camera image-processing system offers. Choose a subject that has a variety of colors and make settings and shots with a variety of color tone shifts. Open a set of images in your computer and compare the shifts and how each step of change in the settings changes the degree of tint on the image.

Advanced Option

If you have Photoshop, open a color image and then go to Image>Adjustments>Variations. This control is very similar to the Color Shift or Color Bias option in the camera image processor but, as you can see, has infinitely more controls.

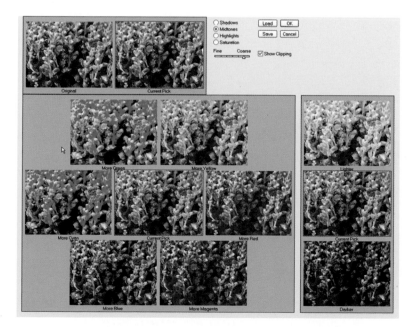

Black-and-White Mode

Black and white has a long and honored tradition in photography, and many of the most memorable images have been photographed in black and white. Black and white (actually, grayscale) hones in on the design, form, and texture of subjects, and removes the distraction of color to allow us to come closer to the image content—and, often, the photographer's intent. Color is a digital camera's default way of seeing, but you should certainly explore black-and-white options, as well. With new printers and inks that bring richness and longevity to black-and-white prints, digital has, in fact, spawned a revival of black-and-white photography.

Available through most camera menus, the black-and-white mode allows you to make monochrome photographs with all the controls and creative options afforded to black-and-white film photographers, and more. You access black-and-white mode through one of the creative menus. It might be a subset of what is called Image Optimization in some cameras or Picture Styles in others. Either way, the mode, at its most basic, simply "desaturates" (removes color, and retains the light and dark tonal gray values) the image when it's processed in the camera. You can also combine black-and-white mode with other settings, such as higher contrast and sharpness, for even more effects.

Another option in the black-and-white mode is to emulate the effects gained when you place *color contrast filters* over the lens. These filters are used by black-and-white film photographers to enhance the way tone is rendered on film. Although the image is recorded on the film in black and white, the way color light is transmitted has an effect on the black-and-white tones that express those colors on film. For example, if you want to lighten how red subjects look in your black-and-white image, and darken the greens, use a red filter. If you want to enhance the way green foliage records in black and white, to get more detail in leaves, use a green or yellow filter.

Switching to black-and-white mode usually switches something in your mind and alters how you see light, shadow, and texture. If you're photographing with a DSLR, you won't see the image in black and white in the viewfinder, so you need to develop a "monochrome sensibility" as you work. Non-SLR digital cameras might actually show the scene in black and white in the electronic viewfinder or LCD monitor.

There are quite a few options in black-and-white mode, including some that emulate traditional darkroom processing effects such as sepia toning. Keep in mind that you can vary these effects by combining them with Saturation and Contrast settings, as well.

Straight black and white

Sepia

Try It

Choose black-and-white mode, and leave it set on your camera for a day's shooting. As you photograph and review your images, see what works for you in black and white and what might best be in color. Look for scenes with deep shadow, strong textures, and a range of brightness values. As you work, begin to see how tones translate from color to black and white, and how to best exploit the potential of the monochrome medium.

This set of images contrasts the way light and dark tones record in normal color mode (above left), in straight unadjusted monochrome (above right), and with some adjustments to the black-and-white version (left). In the final version, I chose an orange filter effect to deepen the blue sky. If I had wanted the blue to record even darker, I could have used a red filter.

Another option in monochrome mode is to add a color cast to the image. Unlike the color contrast filter effects, which change how certain colors translate to lighter or darker tonal values and don't colorize the image, this option—like the sepia effect—emulates how a print bathed in toner or mordant dye would appear. There are many options, from purple to blue to green. Above right is the blue cast on a monochrome exposure.

How It Works

When any monochrome camera setting is chosen, the image processor removes color from the image information but does not remove the red, green, and blue channels in the image structure. This is known as *desaturation*, a technique that also comes into play in software image manipulation. When one of the color casts are chosen, the desaturated image is, in essence, washed with that color. If you use black-and-white mode with JPEGs, you cannot reverse the effect and regain color later in the computer. However, if you shoot in raw format, you can photograph in black and white and later turn the image into a full-color photograph using the raw converter software.

Advanced Option

As you work in black-and-white mode, play with image character settings, such as Contrast and Sharpness. Apply the color contrast filter effects for landscape shots. Find a scene with blue sky and white clouds and photograph it with no filter effect and with yellow, orange, and red filters. Compare the results.

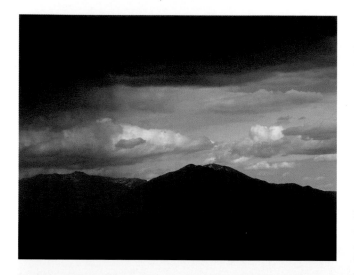

I made this series of four photographs outside Taos, New Mexico, along a fairly standard horizon line vista. The light in the sky shifts from dark to light from left to right. It's important in such scenes to make an exposure reading for one frame and then lock it in, or switch to Manual exposure and keep that one exposure constant, on every frame you're going to use for stitching. This is a great aid in blending the images together.

The final image shows a good blend of values and no "hitch" in the horizon line. I created it in Adobe Photoshop using the Merge tool. Most every image-editing and -manipulation software program offers this function. I cropped the final result slightly to provide a rectangular, panoramic frame. Long roll adapters on inkjet printers allow you to make very wide and narrow prints, great for panoramic scenes.

Digital Filter Effects

Traditionally, filters screw onto the front of the lens to alter the character of the light passing through. Filters could impart just about any optical effect, from warming up the light (with a slight yellow cast) to diffracting it into starburst highlights. Digital photography and image-manipulation software have, for the most part, eliminated the need to use such filters. Virtually any effect attained with these filters can be emulated in camera or later in processing.

The only two types of filters that cannot be emulated with digital filter effects are the polarizer and the neutral-density (ND) filters. A polarizer can aid in eliminating reflections from glass and water, something that software can't yet do; neutral-density filters cut down the amount of light coming through the lens, aiding in the ability to use slow shutter speeds in bright light when the ISO is already set to the lowest available. Beyond that, there isn't much digital filters can't do, from more common to quite amazing tasks.

How It Works

Digital filters in the camera menu are preprogrammed instruction sets that are applied to the image during in-camera processing. Many of these effects can also be attained later in image processing in the computer. Some of these effects can be as simple as adding a warm cast to the image. More complex instructions might be to create starbursts out of highlights or to add a soft-focus blur. Filter effects can also be a part of Scene modes in some camera models. Camera manufacturers usually limit the number of filters in their digital cameras, knowing that many of their effects can be created later, but there are usually some in all but the most professional-grade camera models.

Try It

Check your camera instruction manual, and explore your camera menu for various filter effects. Choose an effect and seek subjects that could be enhanced through its use, remembering to shoot *before* and *after* versions (without and with the filter effect) so that you can compare them later.

Advanced Option

Store your before-and-after shots in a folder titled "Filters," and open the images in your image-manipulation software program. Open the "before" shot, and try to emulate the filter effect of the "after" shot on it in the computer. Then compare the time it took you to accomplish the effect in the computer with the time it took you to set up the effect in your digital camera when you made the shot.

I achieved this soft-focus effect by simply choosing Focus Blur from the special effects menu in my camera. I turned the flash on to brighten the highlight values and enhance the effect.

Special Effects

In addition to the basic digital filter effects, there are also a number of special effects available in camera. Some are created by working with extreme combinations of the image character controls already discussed; others are functions available only in certain cameras. Check your instruction manual to see what you might have available in the special effects realm, and give them a whirl. You can also use add-on lenses and optical glass that might allow you to get extremely close to a subject or play with selective focus and blurring right in the camera.

Posterization

The posterization effect (sometimes called solarization) makes fairly drastic tone and contrast changes. If your camera lacks this feature and you'd like to try it, the effect is also available in most image-manipulation software programs.

While special effects can be applied to any image, it's more effective if you try to match certain subjects and scenes with particular effects. This pile of ropes and floats works well with the more graphic rendition created by the posterization effect. The change is simple push-button one, but be aware that once you apply such changes in camera, you cannot reversed them in software later. If you want to experiment, always shoot one version with no effects and one with.

There is no lack of special effects available in software programs; along with those in the popular image-editing and -manipulation programs, there are hundreds of plug-ins (programs that add capabilities to software) and stand-alone software programs that can do just about anything you want to an image. These programs go beyond the basic fixes of color, contrast, and exposure control—they offer "tricks" that allow for push-button variations that can, for example, make a photo look like a painting from just about any period in art, from classic to impressionistic to postmodern. These trick programs can be fun and fascinating, and many are available as trial downloads on company Web sites.

Multiple Exposure

Creating montages and collages in software is comparatively easy. You can combine any number of images by using Layers, cut-and-paste, and transparency techniques. Perhaps that's why not many cameras offer Multiple Exposure functions. Those that do offer additional multiple exposure features, such as Transparency options, for each shot, as well as exposure overrides to make sure excessive overexposure doesn't occur.

I made this photograph with three exposures, changing the camera zoom and point of view on each. The in-camera software allowed me to make a Transparency selection for each shot, which made the denser and the ghosted areas play off each other.

Infrared

Perhaps one of the most interesting in-camera effects is the emulation of infrared black-and-white film. Used with the right filter, this type of film "sees" into the usually invisible infrared spectrum and provides an ethereal look to many scenes, particularly portraits and nature landscapes. This look can be achieved with software to a certain extent, but it is perhaps more engaging to see results in the field as you shoot. There are two ways to create this effect. One is to work with cameras that will yield an infrared emulation when a deep red filter is placed over the lens. You can tell if your camera will allow for this by pointing a remote control at the camera and looking on the LCD to check if it "sees" the beam.

If this doesn't work, the other way is to have a camera modified to eliminate the infrared blocking filter that most digital cameras have and shoot with a filter that only allows IR light through the lens. This has to be done by a qualified service shop. In both instances, an Internet search will yield both infrared-capable cameras and companies that modify cameras to be IR-capable.

I made this photograph with an IR-modified camera. A deep red filter was placed over the lens to enhance the effect.

Selective Blur

Using Layers and blur effects, you can create images with various parts in and out of focus, regardless of the sharpness or depth of field of the original exposure. (Note that you cannot make an image "sharper" per se, although you can raise contrast to achieve a sense of more sharpness.) You can enhance these effects in software by playing with various swirling and liquefying filters.

Another way to achieve a blur effect is to work with an accessory lens that alters the nature of the image coming through it. This is more of a photographic technique than a digital one, but it's all a part of photography. There are many such lens supplements that can act as light and image modifiers. Close-up lenses, which are like high-quality magnifying glasses, let you focus closer than your prime lens. Soft-focus attachments, which also screw right into the threads on your prime lens, can add a complimentary blur overall or just around the image edges.

Note that any supplemental lens or screw-on attachment will degrade the image quality somewhat, at least when compared to working with the prime lens. But given the use of higher quality accessories, that sacrifice should not be too great.

This effect was achieved using an accessory lens called a Lensbaby. Once the lens is mounted onto the camera, the bellows that attaches the front element to the body can be twisted and turned in any number of ways to yield some fascinating effects.

How It Works

Special effects are generally the domain of software programs. It is in those programs that you have the most control over the effect and its variations. These effects include those native to your main image-manipulation program, as well as plug-ins, which work with the host program to add quite specific effects and changes.

Given that the in-camera microprocessor has the ability to change image character in ways that might be considered more conventional (Color, Contrast, Sharpening, and so on), camera manufacturers often throw in a number of preset special effects capabilities, as well. In general, consumer cameras have more of these than digital SLRs (which are more professional-grade), but all types usually have some. The advantage of using them is that you see what you get in the field immediately after exposure, and they can be fun. The disadvantage is that, because they're presets, you have much less control than if you make the same changes in software after you take the exposure.

Try It

Check your instruction manual, and find the settings in your camera menu that you might consider special effects. Practice accessing them until it's easy, and then go into the field and find a series of subjects that might benefit from the special effects applications. Work with as many variations as possible.

Advanced Option

The emulation of various film characteristics (as well as that of many different forms of visual art) is clearly one of the strongest benefits to digital photography and imaging. Pick a period in art, or an expression on canvas or paper, and you can emulate that effect with just about any subject or scene, using a combination of in-camera and software techniques.

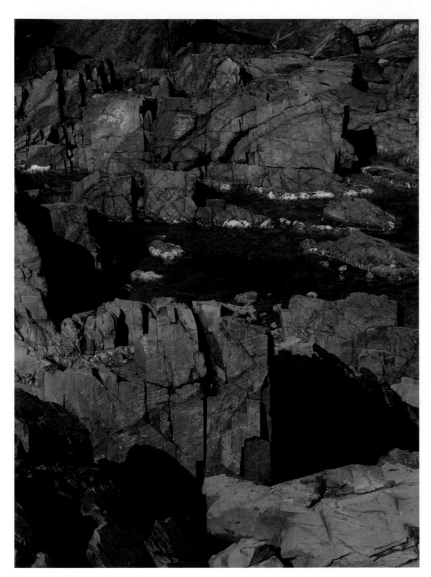

Once you make an exposure, check the histogram. Diagnose what might be lacking and take corrective steps. In some cases, especially when there seems to be some underexposure but the shadow values are not clipped, the image can be fixed in software. Here's an example of an underexposed image that I fixed after checking the histogram.

This representation of the in-camera histogram shows a good spread of values throughout the shadow area but none in the area that should reflect the brilliance of the scene's color and light (the right side of the graph). This resulted from reading a brighter area of the scene and not compensating exposure properly (above). From the histogram, it's evident that more exposure is needed. That means opening up the lens a stop or slowing down shutter speed one step.

After exposure adjustments (opposite), the histogram shows a full spread of tonal values throughout the entire graph. The 1 stop of additional exposure brought out all the color and light of the scene, plus it makes for an image that will be easier to interpret or change in any way desired in software. Getting this information in camera gives you many more options later.

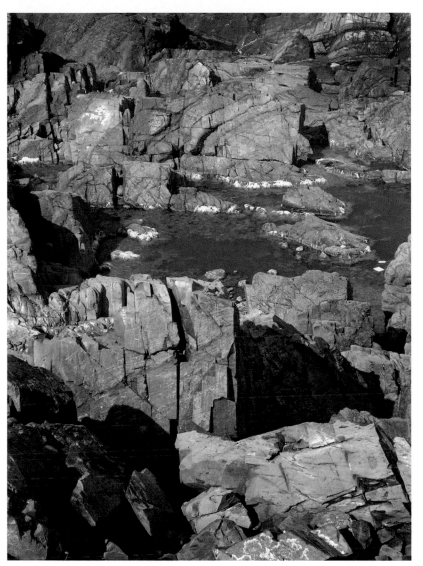

How It Works

The image processor analyzes the range of brightness values within a scene and charts them on a graph. This is an objective mapping of the values and is not a reflection of what you might want to accomplish with the photograph. But as a guide, it is invaluable. The clipping and compressing of histogram values indicates that those light values will be lost in translation and may indicate problem exposures.

Try It

After you make an exposure, toggle through the Playback menu or use the Info button to view the histogram. Make exposure corrections based on the readouts, and compare results. If necessary, intentionally overexpose and underexpose images to learn how histogram readouts indicate poor exposure results.

Advanced Option

Make a series of exposures of the same subject, some in bright light and some in dim conditions. Open the images in your image-editing software, open the histogram or Levels control, and observe the resulting graphs. This will help you gain an intuitive grasp of how brightness value mapping and good exposure and image results go hand in hand.

Overexposure Warnings

Overexposure means that the sensor has been exposed to excessive or too much light. With slight overexposure, you usually have the ability to "fix" the problem in software. More extreme overexposure, however, means there's a loss of texture or detail (and often poor color reproduction) that is quite difficult to fix later.

Some camera sensors handle overexposure better than others, but in general it's best to avoid extreme overexposure whenever possible. It's not that no signal is transferred; it's that the signal is overloaded and will yield a "burnt up" look in the image. If the entire image is grossly overexposed, you might as well delete it; if there are only small areas of overexposure, you might be able to fix them so that the entire image is not a loss.

Camera manufacturers recognize the bad effects caused by overexposure and how they can damage image quality, so many include a visual overexposure warning in the Playback display. The display can be set up so that areas of overexposure blink on playback, with the blink being black, red, or, with some cameras, any color you program. Some cameras can be programmed to show this warning during the quick review right after exposure is made (instant playback on the LCD screen). Depending on the camera model, you might be able to view it using the Playback menu. As you review your pictures, press the Info button; the overexposure warning display will be one of the options.

If the picture shows extensively overexposed areas, you should, if possible, make another version of the same scene and adjust exposure. Your aim will be to reduce exposure or control contrast. You can do this by using minus exposure compensation, by making readings off brighter areas in the scene, by manually closing down the aperture or increasing the shutter speed, or by using fill flash to balance close subject contrast.

This is what an overexposure warning in an LCD would look like. It shows that the trailer, deck, and lighthouse in the background are all overexposed. This is substantial overexposure of important elements in the scene, so I made another shot with less exposure.

In the shot with 2 stops less exposure (opposite), the brighter areas are now well exposed, and the brightest whites have texture and detail. Although this might be considered somewhat "flat" overall, it's simple enough to add "snap" or additional contrast later in software. If the scene were extremely overexposed, then the postprocessing options would be very limited—or the image might not be reparable.

How It Works

The image processor in your camera has numerous diagnostic tools that analyze the tonal (brightness value) distribution in an image. One is the histogram, which shows all the tonal values and their distribution. Another is the overexposure warning, which is simply a graphic representation of those values that are on the overexposure side of the scale. Using blinking lights or a steady accent of color is quite a bit more dramatic than a graph with jammed-up lines at one end.

Try It

Deliberately overexpose a scene, and check the overexposure warning in the Playback menu. Then keep making 1-stop decreases in exposure and checking after each one until the warning disappears or is substantially diminished.

Advanced Option

Learn to use both the histogram and overexposure warnings in tandem. Dedicate a day's work to first shooting and then checking both the histogram and warnings after each shot. This will teach your eye to understand exposure and contrast challenges and how to instinctively overcome them.

Part Three

Memory Cards and Image Downloading

Memory cards are where your digital image files are written after undergoing processing within the camera. These cards are temporary holding places for the files, although you can certainly keep your images on the cards for quite a while if need be. When you first place a card in your camera, it's important to format it, as this sets it up to receive files properly from the camera's image processor. As you work and review your images, you can delete images from the card or protect them from accidental deletion. Most cards can be written to, and read, thousands of times, and can be passed through airport carry-on inspection, although you should avoid carrying them on your person as you pass through metal detectors.

A memory card has a certain capacity, usually expressed in megabytes (MB) or gigabytes (GB). In truth, the cards have slightly less capacity than stated, as some of that space is used for instructions and formatting. As you shoot, you'll see the "exposures remaining" indicator on your camera LED go down. The degree to which each file uses space of course depends on the file format and resolution that you choose. Once you change the format or resolution, the indicator will show how many images you have left when using that format and resolution; change those parameters and a new total will be displayed.

Cards come in various *write speeds*, which indicate the write/read capability of the card. Fast cards (80X and up) are designed to work with cameras that can handle that write speed (the amount of time it takes for the camera microprocessor to place a file on the card). Check your instruction manual; if your camera cannot handle a certain speed, having a fast card won't make any difference, so there's little sense in spending more for it. Similarly, these fast cards are designed to download files to a computer quickly if you have a USB 2.0 or FireWire connection and card reader. With a slower connection, they will be only as fast as that connection allows, be it directly from the camera or via a card reader.

BEYOND THE CAMERA

Memory cards are fairly robust, but there are a few ways to keep them in good shape:

- Never insert cards into the camera, or take them out of the camera, when the camera is turned on—this can cause a short that might corrupt the images on the card.
- Insert the card carefully, and never force the card into the memory card slot. This could damage the pins inside the camera and cause poor or no connection.
- Always format the memory card in the camera, not the computer. After downloading, do not allow the software to erase the images on the card—some will do this unless you decline the option.
- Try to avoid filling the card to maximum capacity, as this might cause problems with the card or with some of the image files.
- If your card won't read or write, you might have what's known as a *corrupted* card. You can usually save the images on the card by using image-recovery software, available from all card manufacturers.

Once you've finished with a shooting session, or have filled up your memory card, you need to download the images to a computer. This frees up the memory card for further use and allows you to work on and archive (save) the images. I suggest that you use a dedicated card reader for this task. You can download directly from your camera, but this can drain battery power, and if you lose power during download, you might lose the images or have to power up the camera and attempt downloading again. Card readers draw power directly from the connection to your computer. Some card readers are designed for one type of card format; the multicard reader can be useful when you have more than one type of camera or might have to download images and data from various sources. There are also small, portable card readers that are ideal for travel.

A 2GB memory card
PHOTO COURTESY OF SANDISK CORP.

Portable card reader
PHOTO COURTESY SANDISK CORP.

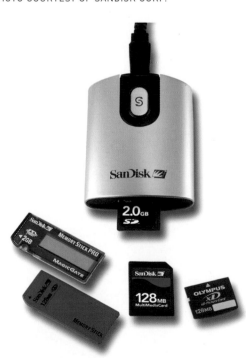

Desktop card reader
PHOTO COURTESY OF SANDISK CORP.

Once you connect the card reader to the computer, via USB or FireWire connection, the computer will "mount" the reader as a drive, which will show up as an icon on your desktop. There are two methods of proceeding. One is to let your loaded imaging software "catch and file" the images; the other is to go directly to the drive, creating your own folder and loading the images into it. Let's deal with the software solution first.

Most imaging software programs, such as Adobe Photoshop and Elements, Apple's Aperture, or iPhoto, are set up to recognize image files. These programs do this by noting the file extension, be it .jpg, .tif, or the proprietary raw file format extension from different cameras. When a card reader is attached, the imaging software will "see" those files and offer to download them into its folders (which are also folders that show up on your directory). There are generally two stages to this process. The first is the downloading of thumbnails (small files) to the screen or software archive, and the second is your signifying that you want some or all of those images to be downloaded. Once you indicate your selections, the program proceeds with the download. You can also caption the file, rename the folder, or otherwise start your sorting of images at that stage. This is a quick and efficient way to download.

The other option is to refuse the imaging software's offer to download and to double-click on the mounted drive. This will open a folder that is usually labeled "DCIM" that you click on again to open. You will then see the folder or folders from the memory card. You drag and drop the folders onto the desktop, which copies them to the desktop. (Note: You might have two or more folders on a card, so be sure to drag and drop only the image folders, as the other might hold formatting information you don't need.) After this, you open your imaging software's browser and inspect the images, deleting those you feel don't make the grade. Then you drag and drop the folder from the desktop to folders in My Pictures, or a similar place in your computer, to take the folder icons off the desktop.

The download screen here shows that this computer has numerous image-editing and -organizing programs loaded, each of which can be used for downloading.

Are there advantages to one system over the other? It all depends on which software program you work with and what's a more comfortable workflow for you. The main task is to ensure that your images have landed safely onto your drive before you remove and reformat your memory card.

The DCIM folder comes up after you double-click on the card reader.

BACKING UP

It is very important to back up, or make copies of, the images that you've downloaded onto your hard drive. You can make copies onto a CD or DVD, or even put the image files onto a separate hard drive. As you might—or should—know, computers can go bad, and having a copy of your images on separate disks or drives is the best way to protect them from harm.

Browser screens may look slightly different, depending on your software, but they all let you view thumbnail versions of the images you download.

Photoshop browser

Windows browser

How It Works

Image-editing software is programmed to recognize certain file extensions, such as .jpg, .tif, or those for the camera's raw file format. When a drive (like a card reader) is attached, the program then imports the files with those extensions into its directory or to someplace on your hard drive. This saves you the trouble of having to drag each file from your camera folder into the drive.

Try It

Make a series of photographs with your camera, and then remove the memory card and place it into a card reader. If you have a software program loaded that's made to download and organize images, click Okay, and let it download the images into its directory for you. Once that's finished, practice dragging and dropping to download yourself. Double-click on the drive on your desktop (the card reader), open the DCIM folder, and drag the folder to the desktop to make a copy. Then, open your image browser, and inspect the images.

Advanced Option

Many programs have a rating system or some other way for you to organize the images once you have them stored. You can also add captions and keywords as you go through your photos after downloading. These cataloging options can be a great aid in finding pictures later. Once you've brought a set of images into a browser or organizer window on your computer, use the program to create one keyword (a word that you can use to search the picture database) for a set of images. Then use that keyword to find those pictures as a set.

Exposure

Processing your own digital photographs will make you a better photographer. Nowhere is this clearer than when trying to fix a poor exposure choice or wrestling with an overexposed highlight that, no matter what you do, won't print as anything but a large, overly bright blob. Working with exposure in software also reveals the incredible flexibility of the digital image file, especially when wringing detail out of shadows, enhancing the range of tones, or perking up color and contrast with a few quick controls. But, the idea that you can fix any poorly made image in software is soon discarded, if only because of the time it wastes that could be spent on more creative tasks.

There are a number of basic software exposure controls that you should master. These deal with both the light and dark areas and the contrast of the image, all of which are tied together. Exposure and contrast also affect color and the perception of sharpness. First, however, you should be able to diagnose what has to be done on the image before applying any tools or controls. The simplest way to do this is using the histogram readout of the image. If the histogram shows clipping (loss of information at the top or sides) or a compression of information from one end in toward the other (over- or underexposure), it will show up immediately on the graph.

One software control available in many programs provides a way to fix contrast using an interactive histogram readout; in Photoshop programs, for example, this is called Levels. The idea is to fill the gamut, or have the tones spread through the available range. This can also be done in Auto Levels or autoexposure in many programs. Of course, not every image benefits from this action, but it gives you a good starting point from which to make more corrections later.

Exposure need not always be bright and "open"; indeed, many images benefit from a moody demeanor or selectively obscured detail. This is where more nuanced controls come into play, a subject of a more advanced software text than offered here. In general, advanced techniques allow you to make "local" rather than "global" changes, or affect parts of the image but not others. But, even when making global changes to contrast and color, you can have a profoundly positive effect on images. This can be accomplished by relying on your in-camera technique to capture exposure and color mood right out of the camera, or by making small adjustments that move the image in the visual direction you desire.

There's so much more information in the shadow areas of a digital image than first meets the eye. It's much better to ensure that you keep highlights and bright areas under control, since it's much easier to reveal detail in shadow than to replace detail in burnt-out highlights.

If scene contrast isn't too high, expose for the brighter areas, and open the shadows later in software when you process the image. Many programs now have an interactive highlight/shadow exposure control, for which you can move sliders that control highlight values and open shadows in the same image. In this scene, I locked exposure on the sky and the building emerging from the fog. The shadow/highlight control let me keep the highlights constant and open up the darker areas to reveal more detail and color.

If you find yourself just on the verge of not being able to make a steady handheld shot, and you have maxed out ISO, simply underexpose the shot by 1 EV (stop), and know that you can easily recover most of the image information later in software. I made the top photograph handholding the camera for 1/30 sec. at ISO 800, the slowest I wanted to shoot at the maximum ISO for the camera I was using. I didn't want to use flash in this locale.

To fix, I added +1 EV in the raw converter software. While doing so, I also tweaked the white balance to make it cooler for a more neutral color balance.

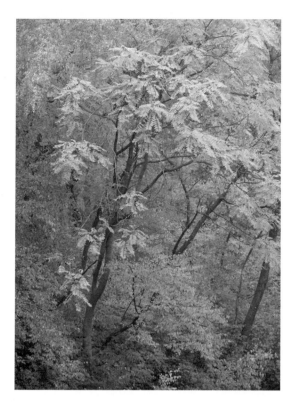

There are two simple ways to judge images on your screen. One is perceptual, when it's obvious that things are too light or too dark. The other is by opening up a histogram, either an interactive one or diagnostic one.

I made the photograph at left through fog, and it has an ethereal feel, but it was just too washed out for my taste. So I checked out the histogram (in this case the one in the Levels control in Photoshop) to see a graphic representation of what is evident to the eye: There's little or no information in the darker or shadow areas of the image. The simple fix here was to move the slider below the histogram from the left to just where it touched the graphic information on the right. This is the first step to "filling the tonal gamut," and you can make further modifications in the next stages of image processing.

The result of that simple "gamut filling" fix is below—perhaps not the end of the processing procedures, but a very good start.

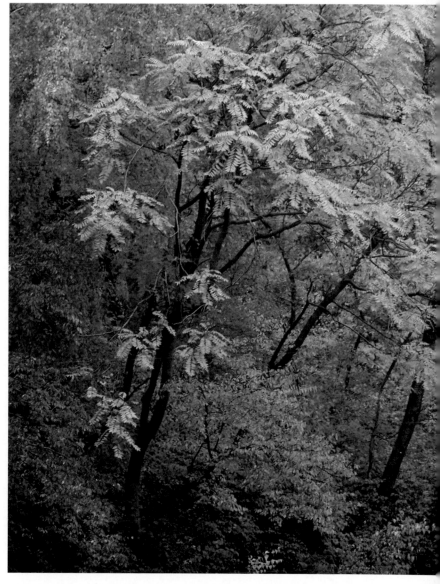

Overexposure of a low-contrast image is not too much of a problem. However, overexposure of highlights within an image, or of a scene with high contrast, causes the biggest headache in digital photography. Some images simply cannot be salvaged.

One of the best insurance policies against this is to shoot in raw format, as the raw converter controls allow for fairly effective postexposure fixes. You can do these fixes in Curves or other processing options, but perhaps the best way is to dial in a lower exposure via the EV control (exposure compensation).

The image at left is an exposure that was poorly handled (the bright highlights didn't receive as much biasing as required to keep them under control). The raw converter screen from Adobe Photoshop was opened (below), and the exposure was adjusted -1.5 stops, which would have been the exposure if the highlights were given proper due in the initial exposure. In the image that came out of the raw conversion (opposite)—with slight white balance tweaking, as well—the highlights are in much better control.

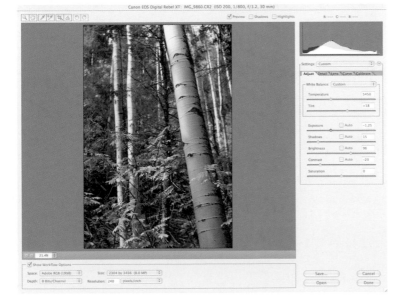

Adv

There
from
capt
and
cutt

Cropping

When you crop a picture, you find the picture within the picture. In essence, you reframe it while eliminating areas from the original scene. This is also called *trimming*. As you look through the viewfinder when you first make the picture, you might not notice distracting elements that "sneak" into the frame. Or, you might not be able to get as close to your subject as you would like.

After you download your images and inspect them, you might notice that there seems to be too much information within the frame, or that there's something not quite satisfying about the composition or the balance of elements within the frame. Cropping can often resolve these matters. It can also enhance photos made with wide-angle or telephoto lenses by helping to focus the eye on the main subjects.

Cropping need not keep an image in its original aspect ratio. There's nothing wrong with cropping to change the height and width relationship (away from the conventional photo rectangle) to make it more effective.

I made this photograph (left) with a relatively wide-angle lens (about 28mm equivalent) to emphasize the leading lines in the snow that direct the eye toward the horizon. With most software programs, you can get a preview of what the crop will look like. In Photoshop, once you set the parameters of the crop using the Crop tool, the part that will be eliminated is grayed out (opposite, left). This allows you to play with options and tweak borders.

The idea behind this cropping (opposite, right) is to increase the sense of depth. By cutting out some of the sky, I tipped the balance toward the leading lines, which become more emphatic as they enter the compressed space. All this is very subjective; the idea is to find the picture within the picture or to refine what stirred you to initially make the exposure.

There's no reason to follow the traditional photographic aspect ratio in your framing. If you want to make prints to hang, you can always make or get a matte that will enclose an "odd-size" print in standard frame sizes. Each photograph will have its own ideal height-to-width ratio; landscapes often seem to benefit from this panoramic treatment. The example here is not a radical crop, but simply removing some of the sky and foreground enhances the scene.

How It Works

Cropping does eliminate file information. It's a good idea to make a copy of an image before doing any work on it, or to be sure to use Save As (not just Save) after you make some changes. That way, you can always return to the original framing and composition without forever committing that image file to a specific cropping. Cropping without preserving the original is like cropping film by cutting off the edges with scissors.

Try It

Gather up a number of landscape images, and work with the Crop tool in your software. Remember to do the work on a copy of the image. After cropping, open the original image and compare. Does the new version bring more balance into the composition? Does it eliminate distracting objects? Does it enhance the photo by getting closer to the main subject?

Advanced Option

The larger the file size, the more you can crop without losing image quality. That's one advantage to shooting with a high-resolution setting. Photograph the same scene in JPEG format first with the maximum resolution setting and then with a low-resolution setting. Crop so that half the image is removed. Compare image quality before and after the crop in both images.

Adding Color

If you consider each digital image file as a beginning, or a sketch that you can build upon, many different variations and image renditions will come to mind. In addition to cropping, adding color can result in an improved—or a completely different—look.

I made this photograph of the Golden Gate Bridge near sundown, but the sky itself didn't provide much drama (left). To reinforce the bridge span, I cropped the photo to a panoramic format. I also added the orange tint using a conventional Fill command (at low opacity) in Photoshop; there are many software programs that offer other tinting and colorizing options.

How It Works

The Fill, or Add Color, command has the effect of adding a wash of color over the image. When you add color in this fashion, you also have the ability to choose the opacity of the color (how transparent it appears over the original image). It is usually best to keep a fairly low opacity and to increase contrast using Levels or Curves. You can also use photo filters and similar tools for this effect.

Try It

This type of colorization usually works best with fairly simple compositions or silhouettes. If an image has too much detail, the technique might get in the way. Find and open such images, and try different color "wash" effects using your imaging software. If your software has layers, use them to control the opacity of the effect after application.

Advanced Option

Some programs and plug-ins (specific, third-party software programs that work in conjunction with a host software) offer a graduated wash or colorization effect. This is similar to the graduated filters often used by film photographers to control the exposure of, or to add density to, the sky. These filters often have numerous customization options, such as overall density, rotation to the horizon, and opacity fading from top to bottom.

The filter used in this image is from the nik Multimedia Classic set, which works in conjunction with every major photo-manipulation program.

Contrast

There are numerous ways to deal with contrast in software. Many programs offer an Auto Contrast setting, a push-button way for the program to analyze and correct what it considers a contrast problem or to simply optimize contrast. It cannot read your mind, so it's not always the best course to follow, although it can get you started in the right direction. It may work for some images but may show little or no effect on others.

The best way to deal with contrast is to use controls such as Levels, Curves, Highlight/Shadow, Brightness/Contrast, burn-and-dodge controls, and so on. Some programs offer more controls than others, but most provide some way to deal with contrast. Quite a few programs offer a control known as Levels. When you open up Levels, the dialog box displays a histogram readout of the tonal distribution within the image. The sliders are the controllers—use the white-point slider (far right) to brighten the highlight value or increase contrast via the highlights (brighter areas) within the image. Use the black-point slider (far left) to deepen shadows. In some instances, you can "fix" an image quickly by opening Levels, looking at the histogram, and "filling the gamut" by moving the black or white point (or both) to touch where the graphic information begins.

Contrast is low but not objectionable here. But it's always a good idea to "diagnose" an image to see what it might hold in terms of tonal values—and where they might be enhanced. One way to do this is to inspect the histogram (as you could when you made the exposure) by using the Levels or similar control in software.

The Levels histogram for this photo reveals that there's little or no information in the brighter areas of the image. This is fairly evident from looking at the image itself, but Levels not only informs you of the condition but allows you to do something about it.

The easiest way to fix this flat image is to fill the gamut by sliding the highlight point (the white triangle) on the histogram to where it just touches the graphic information. This compresses the contrast and enhances the image by bringing in more highlight and midtone values. This is done without changing the gray- or black-point slider, so all those tonal values remain the same.

Contrast problems can often be solved by working with the middle-gray slider in Levels. The highlight and shadow controls (the white and black points) define the overall contrast of the scene, or what might be thought of as the *contextual contrast*. The gray slider can be used to manipulate the "internal" contrast, or the modification of those bright and dark areas. If the highlight is bright enough and the shadows are deep enough, you shouldn't move the black- and white-point sliders, as this will only result in loss of more tonal information. But if the picture isn't quite right, the gray-point slider might still be able to enhance it.

Photographed in late-afternoon winter light, these trees display harsh contrast and obscured detail in the shadows. But the exposure is fine, and detail can be revealed through the use of Levels controls. The histogram in the Levels control reveals that there's a good range of values with which to work. There is some "clipping" (harsh highlight), as shown by the graphic information "crawling up" the far right side of the graph.

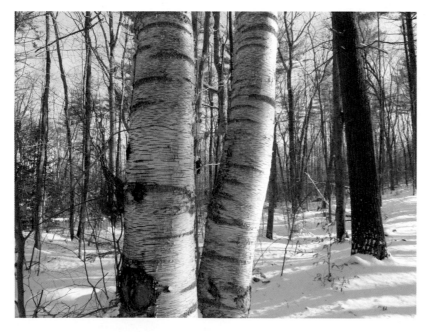

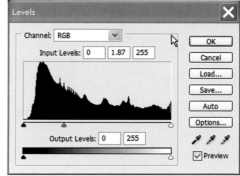

To alleviate some of the harsh feeling in the image, I moved the middle-gray slider toward the black point. This "opened up" the middle-gray values and lessened the harsh-contrast look.

How It Works

Contrast underlies all photographic images, whether they are color or black and white. Contrast is described, however, in terms of black, white, and gray values. This might be easier to visualize in black-and-white photographs, but these values are also components of color images that underlie the hue and determine how bright or dark the color might be.

Levels and other contrast controls in imaging software first display a "map" of the brightness value distribution (the range of light to dark) in the image and then offer controls for its manipulation. The controls allow you to manipulate what is called the *black point* (the darkest values in the scene), the *white point* (the brightest values), and the *middle-gray* values (neutral or middle values). The changes made are actually a reassignment of where certain brightness values sit within, or underlie, the color in the image. If the image seems dull, for example, moving the white point toward the center of the scale increases contrast by replacing the grays with even brighter values. If the darker areas are weak (lack fidelity), moving the black point in toward the center compresses the darker grays toward black.

In both cases, working with the black and white points compresses the available range of tonal values in the photograph. If the overall scene has excessive contrast to begin with, then the middle slider might provide the remedy. It can lighten darker areas with movement toward the black point (as it brightens darker pixels) or darken lighter areas with movement toward the white point (adding gray values to brighter pixels).

Try It

Find and open various scenes that seem dull because of a lack of bright values. In Photoshop, open Levels (under Adjustments in the Image pull-down menu), and move the white-point slider toward the center. Find and open scenes in which going with higher contrast would be excessive (i.e., in which moving the black or white point might be counterproductive but a small tweak of middle values would help), and move the middle-gray slider back and forth. Get a sense of how Levels can make a one-step image fix possible.

Advanced Option

Levels can also be used to work with select color contrast. When you open the Levels dialog box, note the Channel pop-up menu at the top. Click on it and choose a color, such as cyan (blue), and work with adjusting the underlying contrast of the blue in a deep blue sky, for example.

Saturation

Working with images in software gives you complete control over every aspect of color. Changes can be subtle or great, and can be applied to all or select parts of an image, or even to one color itself. As we've seen, color saturation, the richness of color, can be altered at the moment of exposure by the use of in-camera menus. The changes, however, are limited to plus and minus scales, and usually to just within two steps of "normal." Just what is normal, and what change represents a step, is different from camera to camera. Although in-camera alteration of color saturation can be an interesting first step, software controls give you a nearly infinite extension of those choices and of determining just how rich, or how pale, you want colors to be. In addition, you can isolate a certain color and enrich or make it paler.

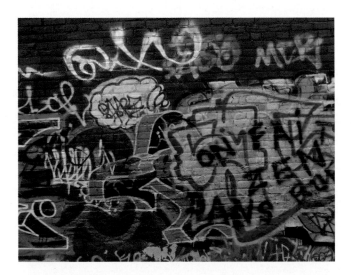

This graffiti-covered wall is a prime candidate for enhanced color saturation, which can be accomplished both in camera or in software. The software controls allow for very fine control over the degree of saturation. Each software program will have a different dialog box, but just about every program offers a color saturation option. Below is the Hue/Saturation dialog box in Adobe Photoshop. It is accessed under Adjustments in the Image pull-down menu. The cursor points to the Saturation control. You can easily enrich all the colors by moving the Saturation slider to the right. The result is opposite.

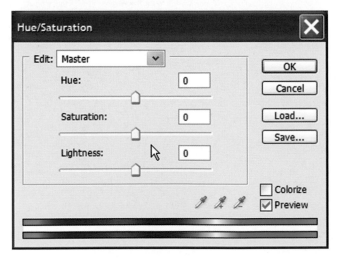

You can also enhance individual colors. Click on the Master option in the Edit pop-up menu at the top of the Hue/Saturation dialog box, and a list of colors will be displayed. Pick the group of colors you want to change. Above left, the Blues option is selected. The blues show up in the dialog box (above right), and you can then choose to add or subtract saturation in the blues—or even swap colors by using the Hue slider.

When the blues are enhanced, they tend to become less recessive, falling back less from the reds in the final image. Enhancing saturation is like spicing a dish: It's very much a matter of taste.

How It Works

As with most software controls, changes in saturation really are pixel "address" changes that you make to override the original information. With this technique, you are not altering the hue of a color, just its richness, thus increasing the inherent contrast of colors or a particular color. Color saturation can have a profound effect on a subject or scene. It can cause certain colors to dominate and others to recede. It can affect the composition and perception of the subject as much as how you might crop or frame it.

Try It

Open a portrait, a landscape, and a color-rich composition (maybe a vase of flowers or a graffiti-covered wall). Use the Saturation controls on each. Some will benefit from enhanced saturation; some might not. Notice how saturation alters your perception of the subject or scene.

Advanced Option

Open the Saturation dialog box in Photoshop, and choose one color for saturation changes, picking a color that might have a number of tints within the scene (such as a variety of greens in foliage). Use the cursor and mouse, and click on one of the color varieties. This will hone in on that color tint to the exclusion of the other tints of that color. Then, play with the Saturation slider. This will enhance the color contrasts even within one hue range, which the overall Greens choice from the Edit pop-up menu will not.

Transforming

When you download your images to the computer, you have begun the process of *transforming* the data into an image. That transformative process is both literal and figurative; you are literally bringing bits and bytes into an environment in which they can be seen as a cohesive image, *and* you are figuratively shaping that data to create an expressive image. The expressive part is what interests us here most.

The tools with which you do this vary from software program to software program, but most allow you to enhance and change color (including hue, saturation, and lightness); tone (the light and dark areas, and how they might be enhanced); and contrast (the overall visual feel of the image). There are also many tricks and special effects available, many with push-button ease. While the content, point of view, exposure, and contrast of the recorded image made in camera is certainly the foundation of any work that might follow, as much, if not more, can be done to the image at this stage of the work. In essence, every image you expose is a sketch of what can follow, the first strokes on a canvas of a work that image-manipulation software completes.

Some images will require very little postexposure work. They speak for themselves and might only need a slight change in contrast or a bit more enrichment of color. Others might need more corrective work, and may be worth the effort and time it takes to make them more pleasing to your eye. Still others will spark something in your imagination and lead you down some other, more fanciful road. The desktop-processing environment lends itself equally well to all these tasks.

You can move the data about in many ways. The computer and software let you "point and click" to tools and commands that alter codes that in turn translate into visual changes in your image. This setup is called a "graphical user interface," which means that you work with icons and motion (the mouse or stylus) to write and rewrite code.

To illustrate the incredible transformative powers of software, here's a set of images that I changed with the Transform tool in Adobe Photoshop. I made this photograph of a door in the French Quarter of New Orleans from a low point of view with a very wide-angle lens, which distorted the shape of the doorway. The perspective needs some correction (opposite, top).

The Transform tool in Photoshop works as if you had a perspective control (PC) lens on the camera. A PC lens is one that you can tilt to make up for point of view. PC lenses can be used on digital SLRs but are quite expensive. If you make lots of architectural photographs, though, such a lens might come in handy—or do you think software can take its place? The Transform tool allows you to "squeeze in" certain edges of the image to create parallel lines, replacing those that otherwise would appear to meet at a vanishing point somewhere in the distance. However, there is some loss of the rectangular frame and image information as a result (opposite, bottom).

There's still some trace of barrel distortion (the slight bulge in the center of the image caused by a lens fault), but the transformation of the image is remarkable. Perhaps this example doesn't have the vivid impact of posterization or other special effects filters, but the ability to "fix" perspective in a few seconds is quite amazing. It is even more so to those who understand the optical gymnastics involved.

How It Works

Imaging software sets up a type of game environment in which certain tools and commands have an effect on an image by rewriting part or all of the code that represents that image. These digital tools are built around traditional artist's and photographer's tools and techniques (pens, paintbrushes, burning and dodging, masking, and so on) and emulate those tools but, in actuality, are simply code writers. The processing power and, especially, the efficiency of the application of that power is very impressive, given that changing an area from, say, light blue to deep blue requires quite a bit of number crunching and a manifestation of that change on a monitor—all in a split second.

Try It

When you first bring an image into a software environment, play with a number of the controls and tools that might emulate traditional tools and techniques with which you are already familiar, such as the paintbrush and painting, for example. If you have worked in a traditional darkroom, play with the corresponding digital techniques that might be familiar to you, such as the burn-and-dodge tools.

Advanced Option

Find a number of images that require some perspective "correction." In Photoshop, first go to Select>All. Then go to Edit>Transform, and work with the Perspective and Skew options. Create parallel lines where there are lines that originally appeared to meet at a vanishing point. Conversely, open an image with parallel lines and make them meet at a vanishing point.

Interpretations

Think of a digital photograph as a sketch, as a first go on interpreting what you see around you in your own personal way. There are times when you can refine the sketch by enhancing contrast or color, or by some judicious cropping; these are mostly corrective procedures that can be applied to just about every photograph you make. Then there are the more interpretive software procedures that you take as the starting point on a visual journey. Of course, not every picture you make requires, or even should be given, this treatment—most photographs tell a story without the use of any special effects. But digital does allow for a great amount of experimentation and play, and it's kind of a shame not to take advantage of that.

There are, literally, thousands of ways you can easily play with images, from so-called plug-ins to simple digital filters and techniques common to every image-manipulation program. This book is not a Photoshop, Painter, or other software program guide. The idea here is to encourage you to play with images and to consider an image as something you can use for further creative exploration.

When I made this photograph on an overcast day in Boston Harbor it was not from any visceral reaction to the light or the moment, but with the intention of making a "sketch" that I knew I would play with later. I liked the lines and forms, and the way detail receded into the mist, but knew that this "straight" shot wouldn't be my "final."

The first steps in software were to crop the image and straighten the horizon line. All you need to do is choose the Crop and Straighten options in your software, and the program will automatically take care of the borders.

The next step was to add some grain. To get this effect, I used a digital filter (a one-step application of an effect to an image) called Film Grain. You apply a digital filter by simply choosing it from the Filter menu in your software, and there are usually options that allow you to modify the effect in numerous ways. Most programs have filter "galleries" that show you the effects.

I finished up by adding some color, using the Hue/Saturation control and darkening the image through the Brightness control. These are common and easily applied effects available in every image-processing program.

How It Works

Photographing "sketches" has nothing to do with technical matters. It is more of a way of thinking about pictures and what you might want to do with them. As you gain experience with software techniques and options, your creative eye will expand to recognize many more subjects and scenes as potential images—the key word being *potential*. This is when what you record with your camera and what you do with image-processing software meld into a 50/50 affair; it's photographing with an understanding of how you might "re-create" the image later.

Try It

Explore some of the filters in your image-processing program, and make a note of two or three that attract your eye. Go out and photograph with those effects specifically in mind, remembering that you can adjust color, contrast, and exposure, as well, on top of the filter's effect.

Advanced Option

Choose an effect; then, go through images you've already made, and make a selection of images on which you will apply that effect and some modifications. Create a gallery of images from that set, keeping in mind a consistent theme or approach.

Unlocking the Beauty

While this might not be true for every picture you take, inside every image is an inner—and often hidden—beauty waiting to emerge. This beauty might have been what inspired you to photograph in the first place, and could have been lost in translation due to some technical problem or simply because your vision goes deeper than what any camera can record. If there is such an inner beauty in an image, then image-processing software can help bring it out.

There are three basic enhancement modes in any photographic software work-flow—exposure, contrast, and color. With software you can work on each in stages, starting with exposure (light and darks), then contrast, and finally, since the other two stages always affect it, the color. As mentioned previously, you can make these changes globally (affecting the entire picture) or locally (working on select parts of the picture).

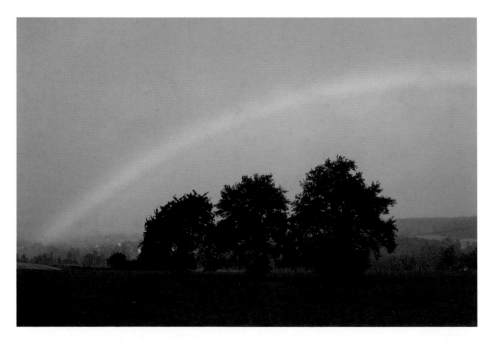

The day was overcast, and it rained constantly, but late in the afternoon, there was a slight break in the clouds and this rainbow formed. It was still pouring, and the traffic was pressing, but I pulled the car over. I was only able to get off a few quick shots before I was soaked and the rainbow disappeared. I also didn't have much time to make careful readings, but I did get the shot.

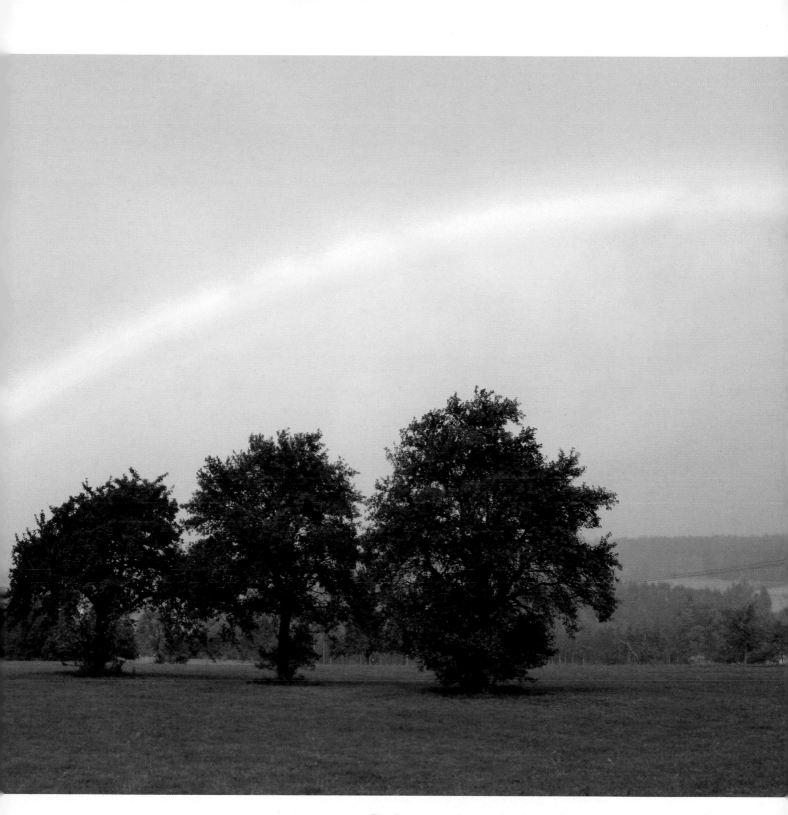

The first stage of correction was to lighten up the whole scene (a global correction) to allow the color and richness of the original light to come through. If an image is too dark, it really is only a minor inconvenience that can be easily fixed.

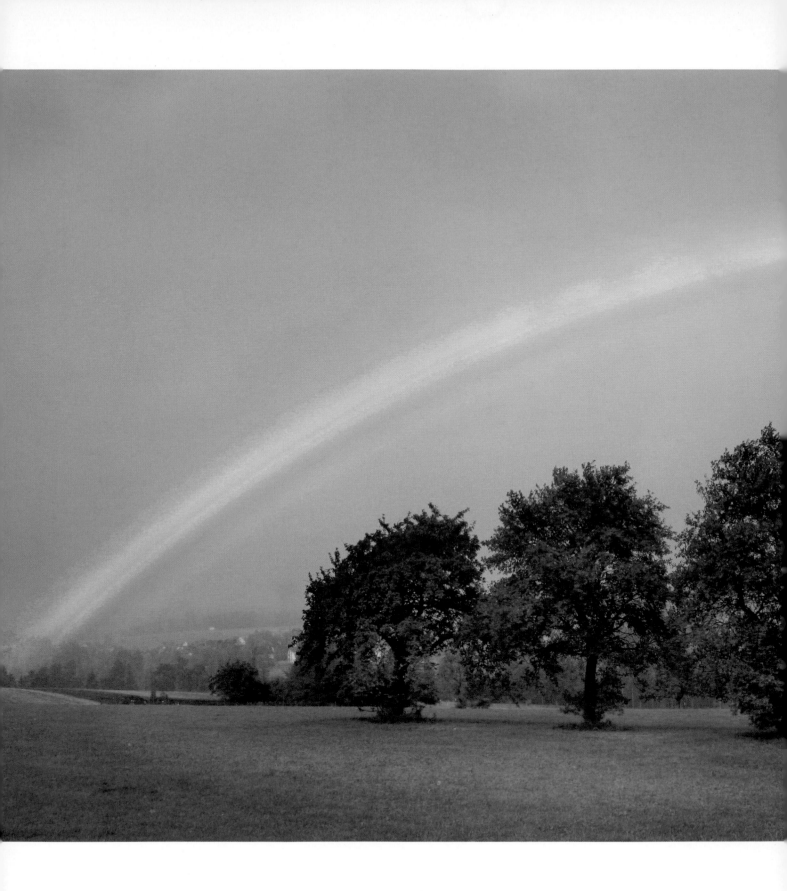

While nothing can truly re-create the brilliant feeling of light and the smell of rain on earth, this version comes as close as it gets and certainly emulates the experience for me.

After lightening the entire scene globally, I increased the contrast slightly, enriching the color without going much darker. Then, I dodged (lightened) part of the grassy area in the foreground, which gave it some sense of depth. Finally, I added a dose of color saturation to enliven the greens and make the rainbow pop. There's was nothing phony about this work, and no special effects were applied. It was simply a matter of revealing what was already in the image.

How It Works

Since image information is composed of changeable codes, there are infinite combinations of relationships between color, contrast, and brightness values. This potential for change can be exploited to bring the visual experience of the photograph very close to, or very distant from, what you saw the moment you snapped the shutter. The three main components of a photograph (color, contrast, and exposure) are easily altered using software techniques. The changes are made using common image editing functions available in every imaging software package, even in "freeware" and inexpensive programs.

Try It

Pick an image in your files that doesn't quite attain the goal you set out for it. Consider what you want to achieve, such as having a brighter ground and deeper sky, and work through one problem for each image you select. Learn how to lighten, darken, and change the contrast, and play with hue and saturation.

Advanced Option

If you have a raw image, open it in a raw converter, create a foundation for improvement there, and then save it and move it into another program for more work. Learn how far you can "take" an image in raw and which improvements are better accomplished in dedicated software. If you're working with a raw browser that works in conjunction with your image-processing program, practice moving back and forth between the two until you can do so with ease.

INDEX